W9-BYG-283

How to Paint in
WATERCOLOR

WATSON-GUPTILL
Artists
LIBRARY

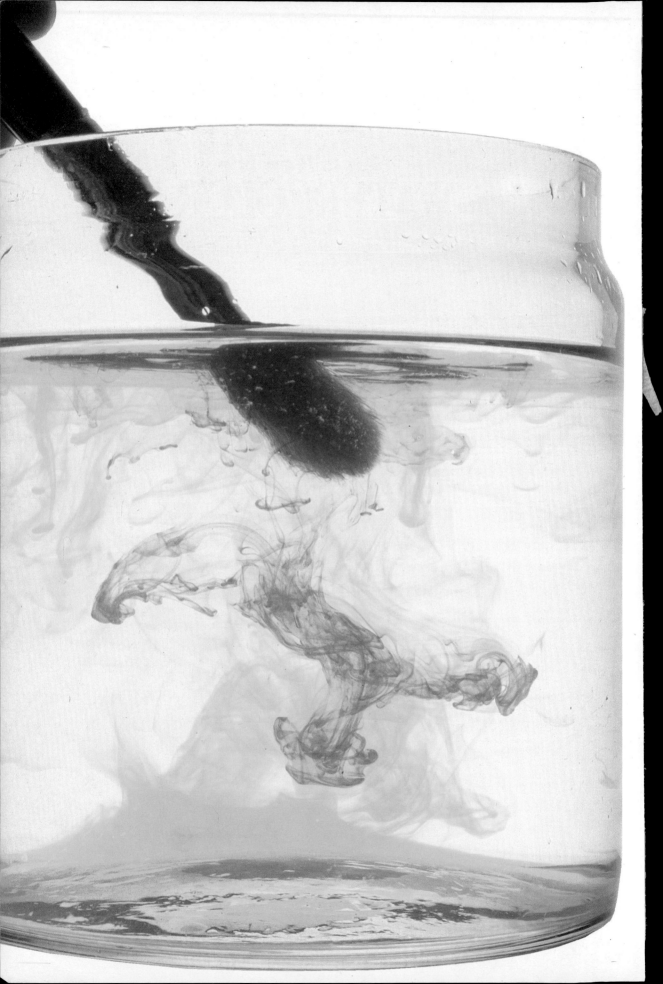

How to Paint in
WATERCOLOR

José M. Parramón and G. Fresquet

Watson-Guptill Publications/New York

Copyright © 1988 by José M. Parramón Vilasaló
Published in 1988 in Spain by Parramón Ediciones, S.A.,
Barcelona.

First published in 1989 in the United States by Watson-Guptill
Publications, a division of Billboard Publications, Inc.,
1515 Broadway, New York, New York 10036.

Library of Congress Cataloging-in-Publication Data

Parramón, José María.
 (Cómo pintar a la acuarela. English)
 How to paint in watercolor / José M. Parramón, G. Fresquet.
 p. cm—(Watson-Guptill artist's library)
 Translation of: Cómo pintar a la acuarela.
 ISBN: 0-8230-2462-8
 1. Watercolor painting—Technique. I. Fresquet, Guillermo.
 II. Title. III. Series.
 ND2420. P313 1989
 751.42'2—dc20 89-5812
 CIP

Distributed in the United Kingdom of Phaidon Press Ltd.,
Musterlin House, Jordan Hill Road, Oxford OX2 8DP.

All rights reserved. No part of this publication may be reproduced
or used in any form or by any means—graphic, electronic, or me-
chanical, including photocopying, recording, taping, or information
storage and retrieval systems—without written permission of the
publisher.

Manufactured in Spain by Sirven Gràfic
Legal Deposit: B.21.060-89

1 2 3 4 5 6 7 8 9/ 93 92 91 90 89

Contents

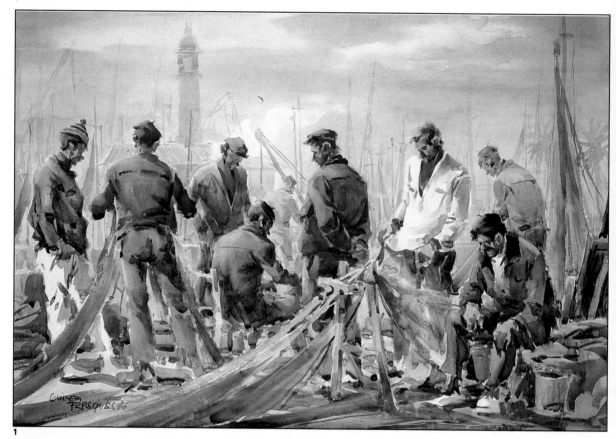

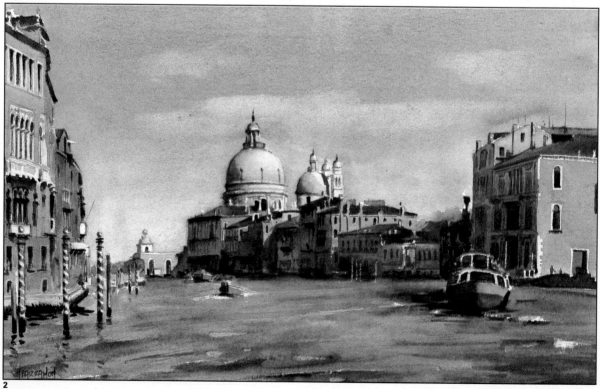

Introduction

A few years ago Guillermo Fresquet, a famous watercolorist, and José María Parramón, a teacher of painting and drawing, famous all over the world for his textbooks on the fine arts, published a book about how to paint with watercolor.

The book was a tremendous success: a few months after the Spanish edition appeared, it was published in France, and over a period of three years it was translated and published first in England, then in Italy, Japan, the United States, Holland, Portugal, and Germany. In Spain it has reached the 20th edition, in France the 15th, in Germany the 10th. All together, 600,000 copies of the book have been published to date.

The reason for this success lies in the fact that Fresquet is a great expert in the art of painting with watercolor, an artist who really *knows* how to paint with watercolor, and Parramón, besides being an artist, is a professional in the art of teaching drawing and painting, a painter who *knows* how to teach.

Now Fresquet and Parramón have worked together once again to revise and extend the contents of that book, adding new material and new techniques and increasing the number of illustrations and graphic examples with new photographs and more reproductions of watercolor paintings, more images, and more color. We, the authors, believe that this is practically a new book, with the same didactic system as the one we published some years ago, but with more up-to-date content in terms of technique and materials and a more dynamic form in publishing terms. In short, we believe that this is an even better book than the first edition, with which 600,000 enthusiasts practiced and learned how to paint with watercolor.

Guillermo Fresquet
José M. Parramón

Figs. 1 and 2 (left). *Group of Fishermen* and *The Grand Canal in Venice,* watercolors by Guillermo Fresquet and José María Parramón, the authors of this book.

The history of watercolor is short; in fact, it really began only 183 years ago when, in the spring of 1804, the Society of Watercolour Painters was founded in England; a year later the Society held its first exhibition. At that time watercolor painting began in earnest; in spite of being shunned and criticized by oil painters, watercolor began to be considered as a means of artistic expression. That was when the first and most famous watercolorists appeared: Turner, Girtin, Cotman, and De Wint—all of them English because watercolor *really* began in England. We emphasize "really" because, many years earlier, Rubens, Jordaens, Van Dyck, and Dürer, especially Dürer, had painted with watercolor, but they considered it a supplementary medium for painting studies and drafts such as rough sketches for definitive pictures painted in oil. This is the history, the short history, of watercolor.

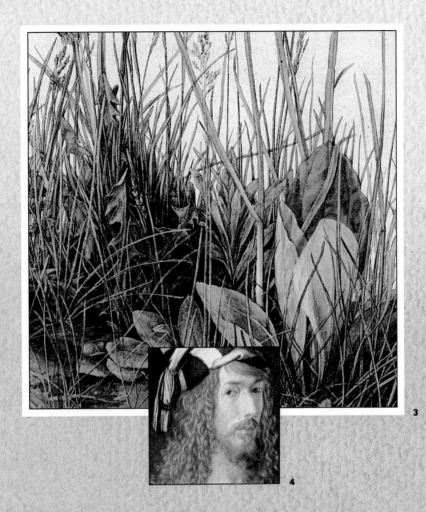

3

4

SHORT HISTORY
OF
WATERCOLOR

The 18th century, era of the "Grand Tour"

In the middle of the 18th century, the English discovered Rome. What happened next was decisive for the art of watercolor.

The period was the height of the so-called *neoclassical* era, an artistic—mainly literary—movement that had a considerable influence on architecture, as well as on sculpture and painting. The aim of neoclassicism was to re-establish taste for the standards of classical art.

The neoclassical movement awoke people's curiosity about the places where the classical civilizations had developed. Athens, and especially Rome, were visited by countless foreign travelers who came to have a close look at the monuments that bore witness to the past: the Colosseum, the Arch of Titus, Trajan's Column, Hadrian's Tomb, the Baths of Caracalla. This was the century of the so-called Grand Tour, when industrialists and businessmen, intellectuals, artists, politicians, and aristocrats—all those who could, inspired by their profession, their sensibility, or by simple curiosity—crossed frontiers to discover other cultures and other countries.

Among the first were the English, who were mostly sensitive and cultured visitors. As a souvenir of their journey to the Eternal City, they acquired drawings of artistic monuments and Roman landscapes, engraved or etched in black or sepia. These drawings, which the Italians called *vedute* (views), were mainly painted by Carlevari, Canaletto, and Piranesi, who made about 400 drawings of *vedute* from which thousands of etchings were copied. In the mid-18th century, the Roman *vedute* were in fashion; by that time artists from all over Europe were working on the theme: the Italians Ricci, Panini, and Guardi; the English painters Pars, Rooker, Cozens, and others. The *vedute* were not only sold in Rome; they were also exported to Britain, where the first copper engravings of drawings were being published, sepia or black

reproductions of landscapes and cities, monuments and flowers, horses and dogs. Almost always magnificently drawn, they decorated the walls of houses and gave rise to the proliferation of the so-called English plates.

Figs. 3 and 4 (page 9). Albrecht Dürer, *Large Piece of Turf* (detail), Graphische Sammlung Albertina, and Self-*Portrait with Glove* (detail), Prado Museum, Madrid. The self-portrait is in fact an oil painting, but the *Large Piece of Turf* is one of the most famous watercolors painted by Albrecht Dürer.

Figs. 5 and 6. Claude Lorrain, *Landscape with River: View of the Tiber from Monte Mario, Rome.* British Museum, London. Below: Francesco Guardi, *Houses along the Grand Canal in Venice* (detail), Graphische Sammlung Albertina. After the Renaissance many artists painted *vedute* of ancient Rome or classical Italy in gouache, or wash.

5

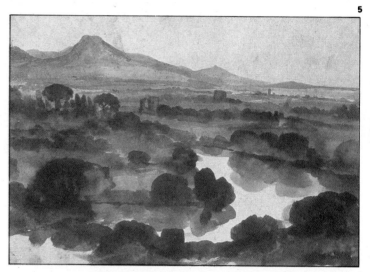

6

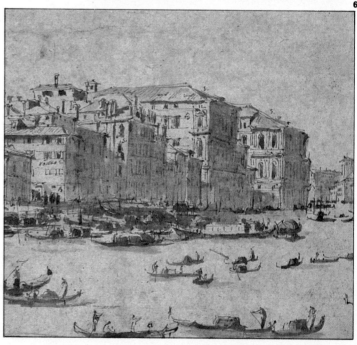

The art of watercolor is born

The use of watercolor began when someone had the idea of coloring engravings and etchings by painting with watercolor on top of the printed drawing. And so, step-by-step, through the hand-painting of etchings, color gradually acquired greater importance until the drawings became watercolor paintings.

Various English artists were responsible for this transformation. Among them were John Robert Cozens and particularly Paul Sandby, who, instead of coloring the etchings as a series, studied different techniques and systems plate by plate and thus perfected watercolor painting.

7

8

Fig. 7. John Robert Cozens, *The Alban Lake and the Castle of Gandolfo,* Tate Gallery, London.

Fig. 8. Paul Sandby, *Landscape,* British Museum, London. This typical English print is an example of. lithographs printed in black and colored with watercolors.

Fig. 9. Michael "Angelo" Rooker, *Gobington, Kent* (detail), Victoria and Albert Museum, London. A typical 18th-century watercolor, whose detail is reminiscent of the minute work in lithographs on stone.

9

Precursors and pioneers

10

But now, if we go back to the beginnings of this short history, we shall discover that watercolor painting has its origins in Egyptian art, when the dead bodies of important persons were painted on rolls or volumes of papyrus. It reappears in miniatures in medieval manuscripts and remains through later periods until the Renaissance. We may also say that it was in the Renaissance that the great precursor of watercolor painting appeared: Albrecht Dürer, the greatest German painter and engraver of the 16th century, who, throughout his "long, ardent" life (1471-1578), as the painter Cornelius said, wrote three books, did more than a thousand drawings, almost 300 engravings, and painted 188 pictures, of which 86 are watercolors.

After Dürer, watercolor was practiced as a supplementary art, used for drafting murals and oil paintings. The great masters of the Italian Renaissance—Leonardo da Vinci, Raphael, and Michelangelo—and the masters of the Flemish school in the 17th century did countless magnificent drawings with pen and brush. While in Rome, the French painters Nicholas Poussin and Claude Lorrain painted landscapes in gouache in a style that is a prelude to neoclassicism and the development of watercolor by the British artists.

Figs. 10 and 11. Albrecht Dürer, *View of Arc*, Cabinet des dessins, Louvre, Paris. Below: Albrecht Dürer, *Hare*, Graphische Sammlung Albertina, Vienna. Dürer was the great precursor of watercolor painting. From the 15th century he painted in this medium using techniques and styles that could be mistaken for those of many artists of today in the photorealist movement. The difference is that Dürer did not paint these watercolors as studies for definitive pictures in oil or tempera, as was the custom at that time, but as definitive paintings in themselves.

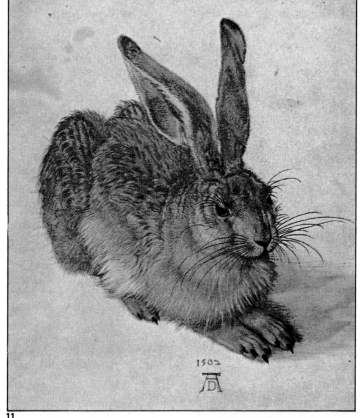

11

The English national art: Turner and Girtin

In the second half of the 18th century, watercolor became a popular art in Great Britain.

In 1768 the Royal Academy of Arts of England was founded. Two of the founding members were the brothers Paul and Thomas Sandby, who were watercolorists. Watercolors were hung at the first exhibition at the Academy. In 1804, the watercolorists broke away from the Academy because they did not receive the same consideration as oil painters. The English watercolorists then founded the Old Water-Colour Society, which held its first exhibition the following year. The English sent 114 watercolors to the Universal Exhibition in Paris in 1855, which amazed French critics and public alike. In 1881 Queen Victoria decreed that the Old Water-Colour Society could put the title "Royal" in front of its name.

By then, watercolor was the English national art.

A decisive factor in promoting watercolor in England, and later in Europe, and elevating it to the category of a medium that could be compared to drawing, pastel, or oil itself was the quality of the pictures of Joseph Mallord William Turner and Thomas Girtin and their contemporaries: Bonnington, Cotman, Blake, Palmer, De Wint, Cox, and others.

Turner was then recognized as one of the great masters of English art, an extraordinary oil painter and fabulous watercolorist. He was admired by Monet, Manet, Pissarro, Degas, and many others, who saw in his work a precedent for impressionism.

12

Figs. 12 and 13. Left: Peter De Wint, *Lincoln*, British Museum, London. Below: Thomas Girtin, *Cayne Waterfall, North Wales*, British Museum, London. Two watercolors typical of English art of the 18th century.

13

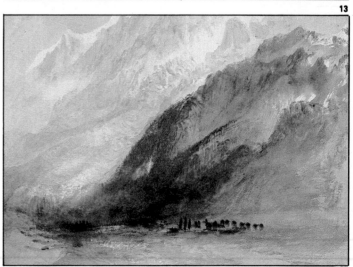

14

Fig. 14. Joseph Mallord William Turner, *The Glacier at Bussons*, British Museum, London. Turner was undoubtedly the finest and most famous watercolorist in England and considered by French artists of the 19th century to be one of the most important precursors of the impressionist movement.

19th and 20th centuries: Europe and America

Richard Parker Bonnington, a leading English watercolorist at the end of the 18th century, was largely responsible for taking watercolor to France, where it was immediately taken up by enthusiasts. Outstanding among them was Eugène Delacroix, who painted watercolors and wrote pages of notes—his famous "diary" with sketches of Morocco—while he was traveling through North Africa. He used them later in his paintings of Arab scenes and characters. We should also mention Gustave Moreau and Eugène Lamisse, who founded the Societé d'Aquarellistes in France. Later appeared Paul Cézanne, who interpreted watercolor in his own way within the impressionist style. We might also note, as a curiosity, that the first abstract painting recorded in the history of art was done in watercolor in 1910 by Wassily Kandinsky.

Outstanding at the same time were J. B. Jongkind in Holland and, in Germany, Hildebrandt and Von Manzel, with Nolde and Macke in the first half of the 20th century.

Among the famous Spanish watercolorists of the 19th century were Pérez Villamil and the extraordinary Mariano Fortuny, a prime mover of the first society in Spain, the Centro de Acuarelistas, founded in 1864 in Catalonia and known today as "Agrupació

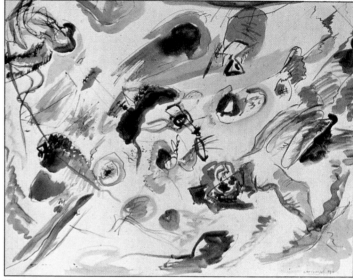

15

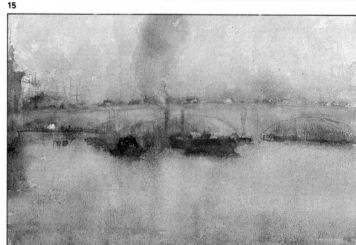

16

Fig. 15. Wassily Kandinsky, *First Abstract Watercolor*, Musée National d'Art Moderne, C.G.P., Paris. This watercolor, painted in 1912, is not only the first abstract watercolor, it is also the first abstract painting in the history of art.

Fig. 16. James Abbot McNeill Whistler, *London Bridge*, Freer Gallery of Art, Smithsonian Institution, Washington, D.C. At the end of the century, Whistler was already painting with the wet-on-wet technique in this magnificent watercolor of the river and boats under a bridge.

17

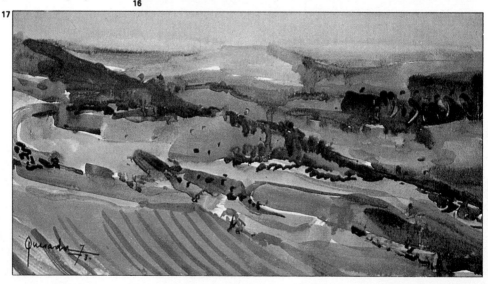

d'Acuarel·listes de Catalunya'', and of watercolor in general, not only in Spain, but also in France and Italy.

In the United States the American Watercolor Society was founded in 1866. At that time Winslow Homer and Thomas Eakins, who painted in oil and watercolor, were already famous. Other important artists were Maurice Prendergast, Mary Cassatt, and John Singer Sargent.

At the end of the 19th and the beginning of the 20th century, watercolor suffered a new period of ostracism, possibly because to a certain extent watercolorists themselves denigrated the characteristics peculiar to the medium in a frustrated attempt to emulate and even surpass oil painting. In the 1920s, however, a new generation of artists took up the torch and reasserted the artistic value of watercolor.

Fig. 17. Julio Quesada, *Landscape*, private collection. Here is an excellent example of the watercolor painting of today, an example of the synthesis of form and the harmony of color, as interpreted by the Spanish watercolorist Julio Quesada.

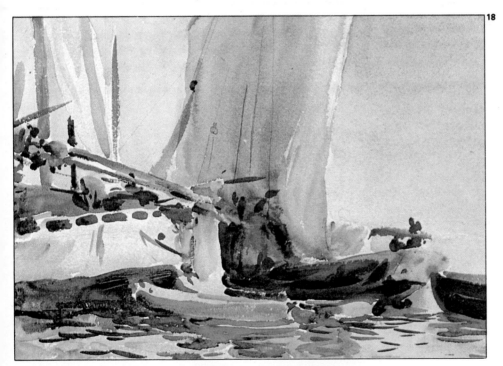

Fig. 18. John Singer Sargent, *Giudecca*, Brooklyn Museum, New York. A master of synthesis, form, and color, Sargent provides us in this painting with an example of this capacity. Note his technique in reserving whites and shapes, and the washes done with a single coat of color.

Fig. 19. Winslow Homer, *The Pioneer*, Metropolitan Museum of Art, Amelia B. Lazarus Fund, New York. Homer was another outstanding North American watercolorist, an artist of reliefs, of great effects of light and shadow done with extraordinary simplicity, as this watercolor shows.

"Cheap is expensive." Do you remember? This phrase is the last word on the subject of materials for painting and drawing. If drawing and painting—drawing and painting well, of course—demand knowledge, call for experience, skill, and a creative sense, qualities not easy to acquire, the last straw is when materials are not suitable, present difficulties, or do not give everything we might expect of them. It is true that materials for drawing and painting are expensive, but you cannot and must not risk your work, your creative capacity, because of poor-quality paper, fading colors that lose their intensity when they dry, or a brush whose hairs do not hold together in a compact sheaf. Our advice is that you paint with high-quality materials—or give up the idea of painting good pictures. As far as tools are concerned, we recommend that you visit a good shop specializing in drawing and painting equipment in order to be in touch with everything that appears on the market, from a new model of table to a special easel for watercolor painting outdoors. They do exist.

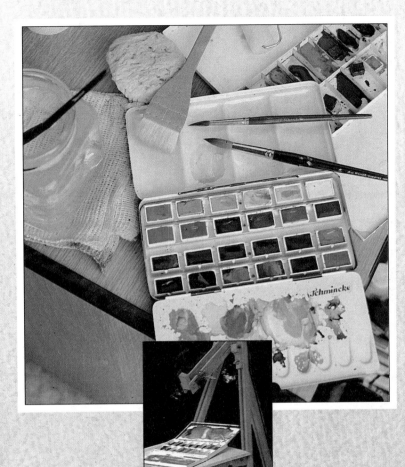

MATERIALS
—AND—
TOOLS

Space, lighting, and furniture

A room to be used as an artist's studio may be as huge as the ones that painters set up in the last century, up to 100 m² (about 1,000 sq. ft.), which served as a studio, a gallery, a meeting place, and a party room, or it can be a room as small and functional as those of some present-day artists, which, with rare exceptions, have dimensions that do not exceed 16 or 20 m² (about 200 sq. ft.).

The studio should have white walls and plenty of light: by day, natural light through the largest windows possible, with curtains or blinds that make it possible to regulate the amount of light, and by night, artificial light, which must be powerful and balanced to create a daylight atmosphere so that you are not restricted from working after the sun has set.

Ask an electrician about the possibility of installing one or more overhead fixtures, each consisting of a battery of four fluorescent tubes, two with warm light and two with cool light to approximate natural daylight.

You should also put in a complementary table lamp with a bulb not less than 100 watts and another light in the corner where you choose to relax, read, listen to music, or talk.

Furniture and tools

Drawing table. Any table will do, provided it can be adjusted to different angles.

Tabletop easel and studio easel. The tabletop easel, the classic easel for watercolor painting, is in the shape of a book rest and can be inclined at different angles up to 45 degrees. The studio easel can be the tripod type or, better, the studio type with wheels.

Drawing board. With these easels or with any other, watercolor painting requires a drawing board that allows you to draw or paint by placing the paper on the solid surface and securing it in place.

Tabouret. Whether you paint at the table or at an easel, you will need an area, a tabletop, where you can have on hand a jar of water, brushes, sponge, paper towels, pencils, paints, and palette box. You can use the other end of the same table, but it is better to have a tabouret next to the easel or next to the table. It is a small table like a bedside table, with drawers and with wheels to move it around.

Sink with running water. You will need to wash brushes, pots, and jars, wet paper for mounting, and wash your hands.

And that almost completes the list, although the following, in my opinion, is also important:

Shelves for books and music equipment. The shelves and the books are indispensable. So is the music equipment. Cheap or expensive, so long as it sounds good; it is very, very pleasant to draw and paint to music. Not background music: music.

Fig. 21. Here is the studio of a modern painter, where the outstanding feature is the natural lighting—daylight flooding in through wide windows on the front wall—and where artificial lighting is provided by the spotlights attached to the ceiling and by the complementary light of the lamps illuminating the two worktables. From the set of tools in the photograph, we should select and comment on these:

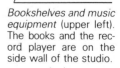

Bookshelves and music equipment (upper left). The books and the record player are on the side wall of the studio.

Stand for files. In a tripod for holding files you can store blank paper, as well as original sketches and paintings.

Tabouret. Like a bedside table, it has a tabletop, drawers, and storage for tubes of color, brushes, pencils, jars for water, fixing sprays, and other paraphernalia.

Drawing table. This one has an adjustable board.

Chair with upholstered back. Choose a revolving one with adjustable height, five legs on casters, and a metal footrest.

Studio easel. Suitable for painting either with oil or watercolor. It has a tray of adjustable height for extra materials and for holding the canvas for oil painting or the board for watercolors.

Extra desk. Provides additional space and drawers for storing materials.

Brushes for painting with watercolors

Various types of watercolor brushes are available on the market. They consist basically of three parts: a varnished wooden handle, a chrome metal ferrule, and a sheaf of hairs held together by the ferrule. The quality of the brushes is determined by the class of hair, and so we can distinguish:

Sable-hair brushes
Mongoose-hair brushes
Ox-hair brushes
Polecat-hair brushes
Stag's-hair brushes (Japanese)
Synthetic brushes

The best of these, and the one most often used by professionals, is the sable-hair brush. The hair of this brush is taken from the tip of the tail of an animal called the kolinsky, which is native to the Soviet Union and China. The sable-hair brush is expensive, both because of the quality of the hair and because of the slow, laborious manufacturing process. The other brushes mentioned are more economical, and some are used as extra brushes. Ox-hair brushes, stag's-hair brushes, and polecat-hair brushes, in the broad varieties, are highly appreciated and frequently used for the task of wetting the paper or doing washes for extensive backgrounds, skies, and so on. The broad synthetic brush is equally useful for extensive washes, and the round synthetic brush, because it is resistant to acid or corrosive liquids, is the only brush that makes it possible to work with bleach or similar products or with liquid gum for reserving (fig. 24).

"But"—Fresquet's last word on this point—"setting apart the use of acids and corrosive liquids, the best brush for watercolor painting is the sable hair. We can sum up the features that make it a fine brush by saying that it is spongy, with a great capacity for carrying large quantities of water and color, for bending under the slightest pressure of the band, for opening out like a fan, painting with broad strokes, and then returning to its original form, never losing its perfect point."

Watercolor brushes come in different thicknesses, which are numbered 00, 0, 1, 2, all the way up to 14 for sable-hair brushes and 24 for ox-hair brushes. Naturally, the lowest number corresponds to the finest brush. This numbering is stamped on the handle of the brush, which is about 20 cm (8 in.) long, including the ferrule.

In spite of the wide range of numbers and thicknesses, four brushes are quite sufficient for watercolor painting:

A round number 6 brush
A round number 8 brush
A round number 12 brush
A flat number 14 or 16 brush (broad-ended)
A 4 or 5 cm broad-ended stag's-hair brush

To complement this range of brushes, you may need a small natural sponge and a foam roller for wetting the paper or painting backgrounds or broad gradations (figs. 22 and 23).

Figs. 22 and 23. These are the only brushes and extra tools you need for watercolor painting. From left to right (fig. 22): a round number 24 ox-hair brush and three round sable-hair brushes, numbers 14, 12, and 8; (fig. 23): a small natural sponge, a foam roller for wetting and painting backgrounds, and a broad Japanese brush (hake), although you can use a synthetic fan-shaped brush instead.

Fig. 24. Besides the sable-hair brushes, there are other classes. From left to right: 1 and 2, typically French wash brushes, made of polecat hair; 3 and 4, Japanese brushes with bamboo handle and stag's hair; 5 and 6, synthetic brushes; 7, mongoose-hair brush; 8, a sable-hair brush (rigger) especially designed for drawing thin lines; 9, a fanshaped hog-hair (bristle) brush; 10 and 11, ox-hair brushes.

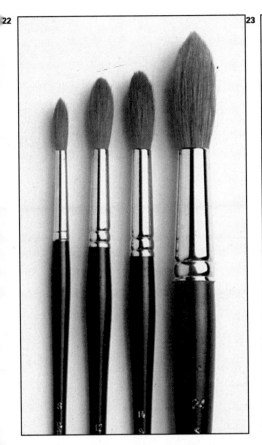

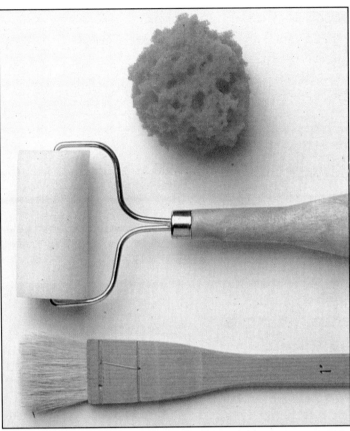

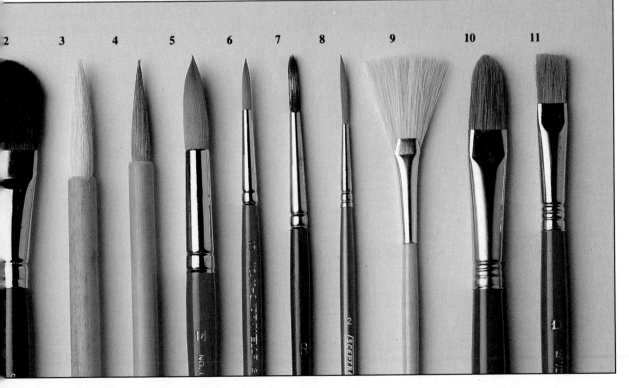

Watercolor paints

Watercolor paints consist of vegetable, mineral, or animal pigments bound and mixed together with water and gum arabic, glycerine, honey, and a preservative agent. The glycerine and honey are added to prevent thick coats of paint from cracking as they dry. Watercolors come in these four kinds:

- *Pans of dry watercolors*
- *Pans of wet watercolors*
- *Tubes of creamy watercolors*
- *Jars of liquid watercolors*

Pans of dry watercolors. "Pan" is a translation of the French word "godet," which means a small container or saucer. Pans contain a measured amount of watercolor, whether dry or wet, and can be round or square, made of white porcelain or plastic. To pick up color, the dry watercolor needs to be constantly rubbed with the brush; it is a kind of cheap watercolor called student quality, and is not generally used by professionals.

Pans of wet watercolors. Wet watercolors come in square pans, and their composition includes a higher quantity of glycerine and honey, which makes them "wetter." They are easy to dilute and of professional quality. They come in metal boxes of 6, 12, or 24 colors and can also be bought in individual colors.

Tubes of creamy watercolors. Packaged in tin or plastic tubes, this paint is creamy and fluid and also of professional quality. It is easy to dilute and can be bought in metal boxes of 6 or 12 colors. Individual colors are also available. The largest tubes are number 5, with a capacity of 14 ml, or about 1/2 fl. oz.

Jars of liquid watercolors. Normally used for illustration rather than fine art, these are extremely intense colors, very close to anilines. In fine art they are occasionally used to paint broad backgrounds or gradations. They come in small glass bottles in cases of 6 or 12 assorted colors.

Setting aside dry watercolors, to be used by schoolchildren and beginners, there is no reason to prefer wet watercolors in pans or creamy watercolors in tubes. Perhaps the latter have the advantage that they can be used immediately, just as they come out of the tube, creamy, half-diluted, and therefore easy to apply when painting large surfaces. When all is said and done, however, the deciding factor is habit, the custom of painting with some colors or others, of painting with a special palette for creamy watercolors (and they exist, as we shall see later) or with a palette box. Just one piece of advice: try both kinds and decide for yourself. Some people paint with both, according to circumstances.

25

5

Fig. 25. Here are the different kinds of watercolors, as well as the boxes and palettes you will find on the market: 1 (above): box palette with pans of dry watercolors, student quality; 2 (center): box palette with pans of professional-quality watercolors; the tray with the pans can be separated from the box, leaving the palette with three surfaces or series of cavities; 3 (upper right): tubes of creamy watercolors and white enameled palette specially for creamy watercolors, with compartments in the center for depositing and arranging the colors; 4 (lower right): jars of liquid watercolors generally used for illustration; 5 (center left): tray of white porcelain pans generally used for preparing color washes for backgrounds, skies, etc.; 6 (inset, lower right): travel set of equipment, including palette box, brush, and plastic jar for water, with pigskin case, for packing with a small notebook when you take a trip.

2

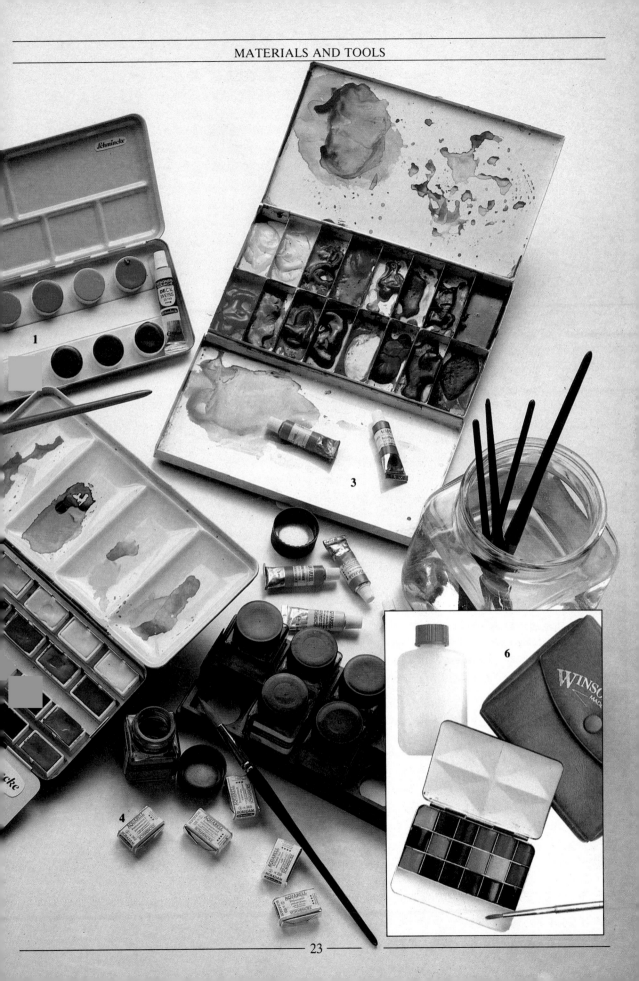

Watercolor chart

Like all color charts, the one reproduced on these two pages shows a range of colors and different shades of each color, which in practice is far more than what you will need. When you go to a restaurant, you may get a menu of more than 50 dishes to choose from, but to eat well you only need 3 or 4. Likewise, returning to watercolor, a professional artist needs no more than 12 colors to do a good watercolor. For example, the color chart shows 5 shades of blue. To paint, you need only 2 or 3: for me, they are *dark cobalt blue, ultramarine,* and *Prussian blue*. But some people say that Prussian blue is too intense—it stains a lot and also has a dominant tendency toward green—so they eliminate it or replace it with *cerulean blue*, which is more neutral, or so they claim. Each painter has a preferred range and palette.

As a curiosity, note that in this and all color charts, *fugitive colors* and *permanent colors* are mentioned, that is, colors that do or do not fade in time when exposed to light. I say "as a curiosity" because, although what the color charts say is true, I think it would never cross anyone's mind to expose a watercolor painting to the sunlight.

Finally, still on the subject of the permanence of watercolors, note that they lose between 10 and 20 percent of their intensity or tone from when they are applied until they dry shortly afterward. This loss of color, less marked in better-quality colors, can be compensated to a certain extent by varnishing the watercolor painting, but this is probably because the varnishing can eliminate the characteristic mat finish of watercolor painting.

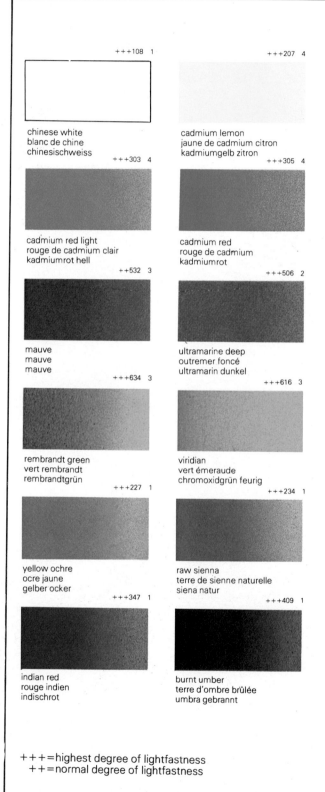

+++108 1
chinese white
blanc de chine
chinesischweiss

+++207 4
cadmium lemon
jaune de cadmium citron
kadmiumgelb zitron

+++303 4
cadmium red light
rouge de cadmium clair
kadmiumrot hell

+++305 4
cadmium red
rouge de cadmium
kadmiumrot

++532 3
mauve
mauve
mauve

+++506 2
ultramarine deep
outremer foncé
ultramarin dunkel

+++634 3
rembrandt green
vert rembrandt
rembrandtgrün

+++616 3
viridian
vert émeraude
chromoxidgrün feurig

+++227 1
yellow ochre
ocre jaune
gelber ocker

+++234 1
raw sienna
terre de sienne naturelle
siena natur

+++347 1
indian red
rouge indien
indischrot

+++409 1
burnt umber
terre d'ombre brûlée
umbra gebrannt

+++=highest degree of lightfastness
++=normal degree of lightfastness

26

This Watercolor Chart has been reproduced with special permission from the firm of **Talens**

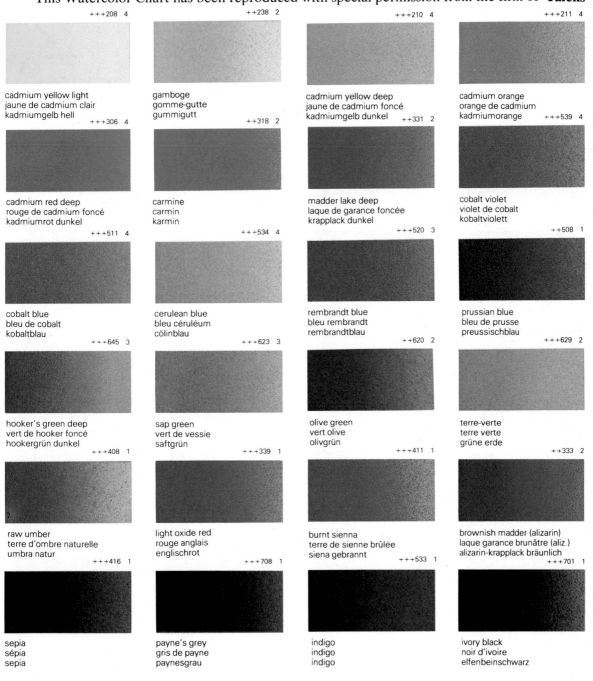

+++208 4	++238 2	+++210 4	+++211 4
cadmium yellow light jaune de cadmium clair kadmiumgelb hell	gamboge gomme-gutte gummigutt	cadmium yellow deep jaune de cadmium foncé kadmiumgelb dunkel	cadmium orange orange de cadmium kadmiumorange
+++306 4	++318 2	++331 2	+++539 4
cadmium red deep rouge de cadmium foncé kadmiumrot dunkel	carmine carmin karmin	madder lake deep laque de garance foncée krapplack dunkel	cobalt violet violet de cobalt kobaltviolett
+++511 4	+++534 4	+++520 3	++508 1
cobalt blue bleu de cobalt kobaltblau	cerulean blue bleu céruléum cölinblau	rembrandt blue bleu rembrandt rembrandtblau	prussian blue bleu de prusse preussischblau
+++645 3	+++623 3	++620 2	+++629 2
hooker's green deep vert de hooker foncé hookergrün dunkel	sap green vert de vessie saftgrün	olive green vert olive olivgrün	terre-verte terre verte grüne erde
+++408 1	+++339 1	+++411 1	++333 2
raw umber terre d'ombre naturelle umbra natur	light oxide red rouge anglais englischrot	burnt sienna terre de sienne brûlée siena gebrannt	brownish madder (alizarin) laque garance brunâtre (aliz.) alizarin-krapplack bräunlich
+++416 1	+++708 1	+++533 1	+++701 1
sepia sépia sepia	payne's grey gris de payne paynesgrau	indigo indigo indigo	ivory black noir d'ivoire elfenbeinschwarz

The figures 1, 2, 3 and 4 indicate the price groups. Colors illustrated are made with the original paint.

Colors in current use

In the adjacent figure you can see 14 different colors under the title "Range of colors for painting with watercolor," a title that may seem too final, as if Fresquet and the writer of this paragraph, your guide and friend Parramón, had chosen these colors from the color chart on the previous page and decided that *these* are the colors you must use. This is not the case. In fact, Fresquet and I have chosen these 14 colors on the basis of the experience we feel we have in the subject after many years of study. And this practical knowledge is confirmed by one outstanding fact: that in their boxes of 12 or more colors, all watercolor manufacturers have made a similar, even identical, choice to the one on this page. In any case, this selection is not inflexible. We simply want to recommend that you begin painting with these colors, which are chosen from our experience and that of the manufacturers, so that in time it will be your own experience that will determine the final choice.

Range of colors for painting with watercolor

Lemon yellow*	**Madder**
Medium cadmium yellow	**Permanent green***
Yellow ochre	**Emerald green**
Raw sienna*	**Cobalt blue***
Sepia	**Ultramarine**
Cadmium red	**Prussian blue**
	Payne's gray
	Ivory black*

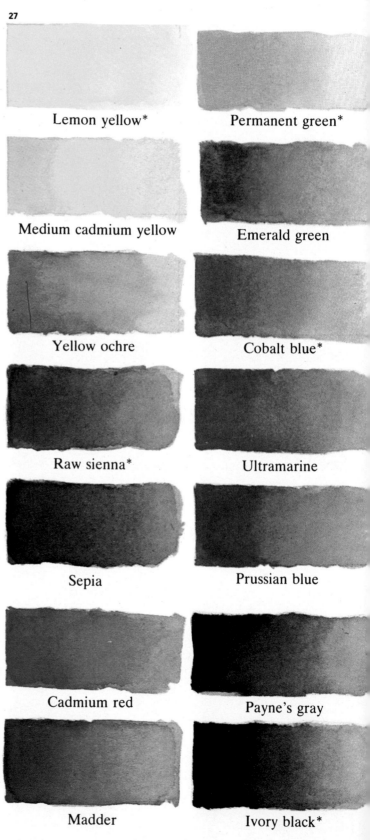

27

Lemon yellow*

Permanent green*

Medium cadmium yellow

Emerald green

Yellow ochre

Cobalt blue*

Raw sienna*

Ultramarine

Sepia

Prussian blue

Cadmium red

Payne's gray

Madder

Ivory black*

Fig. 27. Range of watercolors normally used by professionals. Fourteen in all, which coincides with the colors supplied by manufacturers in their standard boxes (though it is possible to do without the 5 colors marked with *).

Watercolor papers

The quality of the paper can be decisive in painting and finishing the watercolor. Learning to distinguish between the different types of paper and finding out which is the most suitable is an absolute priority.

You should know, for example, that in spite of what is generally said, drawing and watercolor papers can be used on the right side or the back. It is true that the rough surface of the right side is different from the rough surface of the back, but this gives the artist the choice of two textures: the right side, coarse or medium grain, and the back side, medium or fine grain. It is also true that the binding of the paper and the sizing is the same on both sides, which was not the case not so very long ago, when a good drawing paper was sized sheet by sheet by hand and on only one side: the right side.

And speaking of quality, we first have to distinguish between ordinary quality paper, such as the offset type used for printing, which is made of wood pulp and manufactured by machine, and high-quality papers like those made by *Canson, Fabriano, Schoeller, Whatman, Grumbacher,* and others, whose content includes a high percentage of rag and whose manufacturing process is carried out with particular care. This high-quality paper is expensive, and for this reason some manufacturers supply paper of an intermediate quality, just as good for watercolor painting.

Good paper is distinguished by the name or trademark of the manufacturer, which appears on one side, dry printed or marked with the traditional *watermark*, which can be seen by holding the paper up to the light.

Fig. 28. Quality drawing paper. On one edge we can see the typical deckles of handmade paper. In the center are two *watermarks* and one trademark in relief, dry printed, all characteristic of quality paper.

28

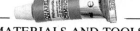

Characteristics of papers for watercolor

Within the range of professional quality, paper for watercolor painting is manufactured in these textures or finishes:

Fine-grain or smooth paper (fig. 29)
Medium-grain paper, medium rough (fig. 30)
Coarse-grain paper, extremely rough (fig. 31)

A special paper worth mentioning, outside the usual line, is handmade *rice paper* imported from Japan. It has a texture or finish similar to a spongy paper, with no grain, but with a touch of gum that makes it possible to work without the paint running. It is used mainly for the technique of *sumi-e*, a Japanese wash technique done with India ink and a brush with a bamboo handle and stag's hair.

Fine-grain or smooth paper is a type of *hot-pressed* paper, a process that leaves paper glossier with less grain. This is a good paper for painting watercolors, especially for the professional illustrator working with aniline paints and an airbrush. It is also good for painting a watercolor with strongly drawn lines, but the artist needs to be expert at painting on a paper like this one, which has practically no grain, because if too much water is used in the painting, the outlines are diluted and the watercolor runs into pools; if too little, the paint dries quickly and "cracks."

Fig. 29 to 31. Here is a full-size reproduction of a sketch painted in watercolor on fine-grain (29), medium-grain (30), and coarse-grain paper (31). This last one, with its extreme roughness, is the usual paper for painting watercolors, ideal for a large picture done by a professional. The fine-grain paper is the best for small watercolors and illustrations; the medium-grain has a roughness much appreciated by many professionals for all kinds of work.

29

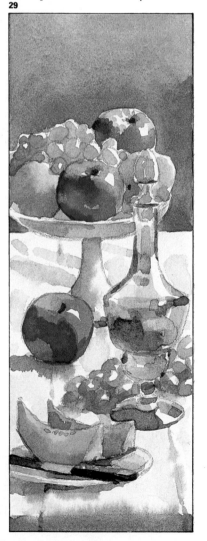

30

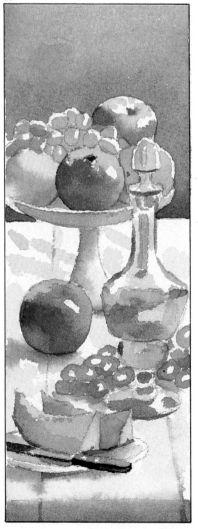

31

With *very rough coarse-grain paper*, the opposite happens. This is a paper specially manufactured for watercolor painting. Its texture has a roughness that appears in tiny hollows that accumulate and hold the liquid watercolor, slowing the drying process. The surprisingly abrupt roughness presents the unskilled amateur with few chances to control the quantity of liquid, to superimpose layers of color, to blend and model forms, and so on. This is the ideal paper for a large watercolor in the hands of an experienced professional.

We are left with *medium-rough, medium-grain paper*, which, naturally, is the one that offers the most advantages

and causes the fewest problems. It is 100 percent recommended, though we advise you to try two or three brands (the roughness or grain of the paper is not exactly the same in each) and choose the one that responds best; at least for a while, experiment and come to your own conclusions.

Fig. 32. These are some of the papers frequently used in watercolor painting. *Approximate* English equivalents are given for reference. From left to right: 250 g (120 lb.) handmade paper (1); 640 g (300 lb.) D'Arches handmade (2); Fabriano in block (3); Schoeller, Parole cardboard (4); D'Arches 300 g (140 lb.) handmade (5); Fabriano 300 g (140 lb.) (6); Canson 240 g (120 lb.) (7); Guarro cardboard (8).

32

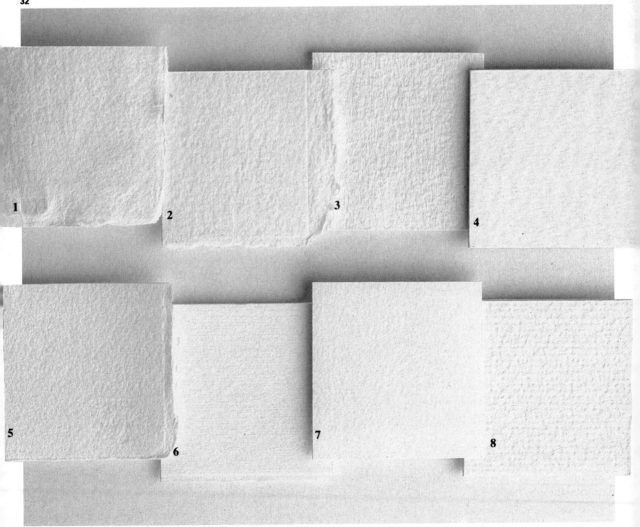

Sizes and weights of watercolor papers

Among the standard measurements for sheets of watercolor paper are:

35 × 50 cm (14 × 20 in.)
50 × 70 cm (20 × 26 in.)
70 × 100 cm (26 × 40 in.)

These sheet sizes are not identical in every country. In England, for example, there are 6 different sizes. The most frequently used is the one called *imperial half*, 381 × 559 mm, and the largest sheet, Antiquarium, measures 787 × 1,358 mm.
Paper is counted by reams and hands. A ream of paper consists of 500 sheets; a hand, of 25. The weight of the ream and its conversion into grams per square meter of paper determines its thickness. A 45 g paper is a thin paper; a 350 g is a thick paper similar to a sheet of cardboard.

Watercolor paper is sold mounted on thick cardboard, as well as in sheets. Mounting prevents warping or undulations in the paper caused by moisture during painting, but it presents difficulties when the watercolor is to be reproduced and printed in color. In the present systems of color separation by scanner, the original drawing or painting has to pass through and roll over a series of cylinders, which is not possible when the original is mounted on a rigid support such as cardboard or wood.

But watercolor paper is also supplied in blocks measuring as much as 35 × 50 cm. The sheets are stuck together at the four corners, one on top of the other, so that they can be moistened and painted on without the moisture causing pockets in the paper. This is the perfect solution, and clear proof is that all the manufacturers supply special blocks, generally of 25 sheets, for painting with wash and watercolor. In the adjacent box you can see, in alphabetical order, a selection of the names of manufacturers of watercolor papers and their country of origin.

Names of manufacturers of quality paper for watercolor painting	
D'Arches	France
Canson & Montgolfier .	France
Fabriano	Italy
Grumbacher	USA
Guarro	Spain
RWS	USA
Schoeller Parole	USA
Whatman	England
Winsor & Newton	England

Fig. 33. Samples of European and American watercolor paper block manufacturers; the sheets of these blocks are glued together at the four corners to prevent the paper from *stretching*, which is explained on the following page.

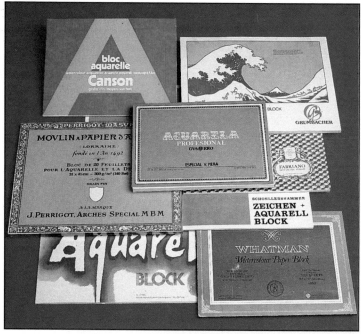

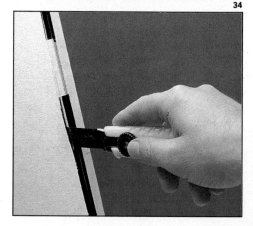

Fig. 34. To separate the sheets of paper in a block glued together at the edges, you slide a cutter between the upper sheet and the block of sheets, carefully cutting through the glue. Some manufacturers leave a small space unglued on one of the edges (indicated with an arrow) to make it easier to slide the cutter in and cut the paper.

Stretching watercolor paper

Stretching paper means wetting the paper and sticking it at the edges onto a wooden board using four strips of gummed tape so that in four or five hours, when the paper has dried, it is stretched and will take the wetness of the watercolor without warping or forming pockets.

Most professionals use paper in blocks, which is already mounted, or a thick paper (350 g minimum), which allows them to dispense with the mounting or to simplify it by stretching the paper with drawing pins or bulldog clips (fig. 40).

So that you understand this technique, in case on some occasion you are working with a thinner paper (less than 350 g), the process for stretching watercolor paper is presented step-by-step in the illustrations below (figs. 35 to 38). Note finally that this mounting can also be done with metal staples instead of the strips of gummed tape, using a staple gun like the ones used by decorators (fig. 39).

Figs. 35 to 38. Here is the process to follow for stretching and mounting watercolor paper to prevent the formation of pockets caused by the dampness of painting. The sheet of drawing paper is wet with tap water for about one minute (fig. 35). Then the wet paper is left on a wooden board and stretched to produce dilatation (fig. 36). Immediately the drawing paper is fixed to the wooden board with a strip of gummed tape along one of its edges (fig. 37). Finally the remaining edges are fixed with gummed tape and the paper is left in a horizontal position for four or five hours. Do not force the drying process with a heater or by placing the paper in the sun.

35
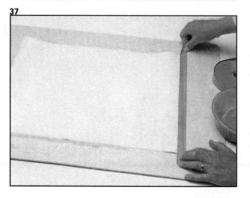

38
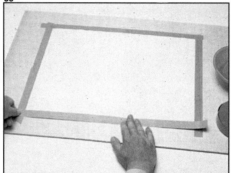

36
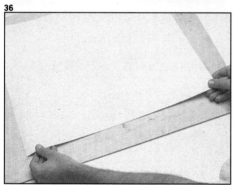

39
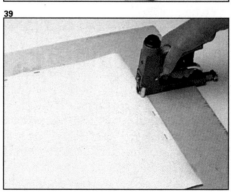

37
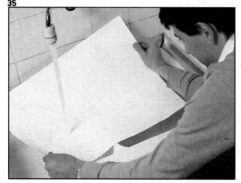

40
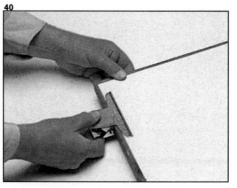

Fig. 39. The stretching of the paper can also be done by wetting and fixing it with metal staples, using a staple gun like the ones used by decorators.

Fig. 40. Many professionals do not bother with stretching the paper; they merely fix it with drawing pins or metal clips without wetting it beforehand. In this case, the paper must have a minimum weight of 350 g.

Water and various materials

Watercolor is diluted in water, ordinary water from the tap. To hold the water, you need a glass jar with a wide neck and a minimum capacity of one liter or quart (fig. 41). Some professionals use two jars of water, reserving one of them for rinsing and cleaning the brush. But both Fresquet and I would venture to suggest that you use only one water jar and not worry about the fact that it becomes dirtier as the picture proceeds. We would even go so far as to say that this rather murky, muddy, grayish water is perfect for balancing color stridencies, for wetting and reserving, for seeing how far the moisture spreads. For painting in the open air, in the country, it is customary to use a plastic container because it is less fragile than glass.

For watercolor painting some supplementary materials are also necessary, such as the ones illustrated and commented on in figure 42. Some of these materials, such as the blotting paper, the liquid gum, or the *medium* for purifying the water are not used by Fresquet, as we shall see on the following pages, but it is good to bear them in mind because other watercolorists do use them, particularly the blotting paper.

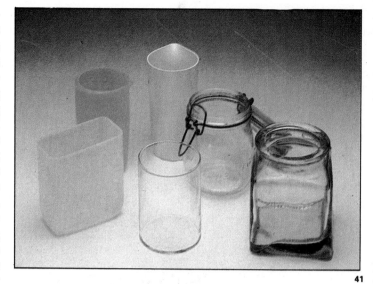

41

Fig. 41. Here are some suitable containers for the water: the glass ones for working in the studio, the plastic ones for going outdoors. They must hold at least one or two liters or quarts, and the neck of the container must be wide.

Fig. 42. Among the series of supplementary materials for painting in watercolor reproduced on this page, we should pick out the roll of paper towels for absorbing the color and squeezing out the brush (A); the liquid gum or masking fluid for reserving whites (B); the brush with a handle that has a beveled tip for "opening" white lines in wet watercolor (C); the cotton swabs for lifting colors in the wet watercolor technique (D); and the stick of white wax for drawing lines that resist water and allow the whites to be reserved beforehand (E). Also worth mentioning is the liquid medium, a solution of acidified gum that, when mixed by means of an eye dropper with the water for mixing the watercolors, eliminates any remaining patches of grease and increases the adherence of the color.

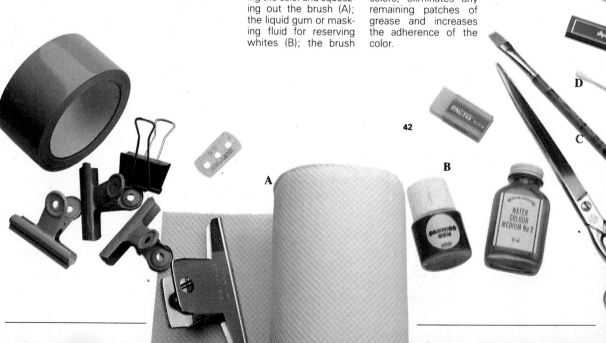

Equipment for painting in the open air

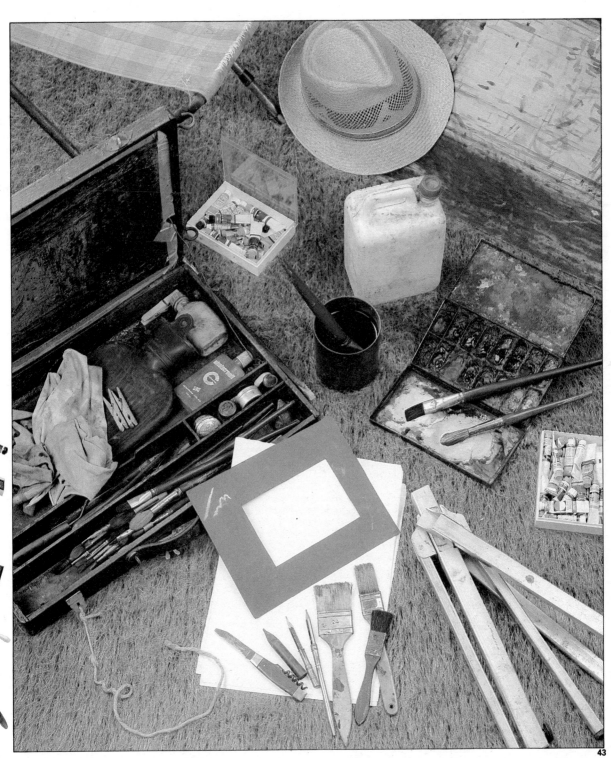

Fig. 43. These are the materials and tools Fresquet uses for painting in the open air. From left to right and top to bottom you can see a folding stool, a straw hat for protection from the sun, tubes of watercolors, a plastic water container, a palette with compartments for arranging the tube colors, a case, a gray cardboard cutout for framing the subject, a folding easel, and a selection of brushes. In the upper right corner you can see part of the board, and under the frame the drawing paper that Fresquet carries around in an ordinary folder.

Now we are going to get down to business, to the practice of watercolor painting, and what better way to try out, to learn, than by experimenting with the technique and skill of watercolor painting without entering into the problems of color and mixtures. There is nothing better than to begin by painting with a maximum of one or two colors, painting in *wash* as many artists, such as Rembrandt, Poussin, Lorrain, or Constable, did. You will be painting a gradation with a brush, with water and watercolor; you will be lifting color, avoiding *cracks*, and you will discover the importance of the white of the paper, of *reserving*. You will practice and learn in the end through *wash painting*, a rehearsal for watercolor painting.

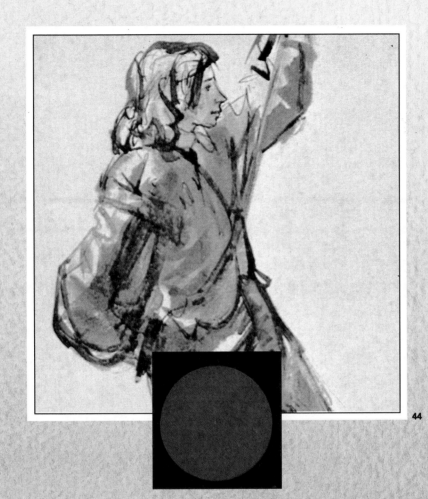

44

WASH:
THE FIRST STEP
IN WATERCOLOR
PAINTING

General characteristics of painting with wash

It is said that wash is *drawing* because it produces a monochrome image, that is, an image painted with a single color, from which a whole range of dark, medium, and light values are obtained. It is said that wash is *painting*, the argument being that while it is monochrome, it is painted with color and worked with a brush, a tool that has more to do with painting than with drawing. There are people who call it a washed drawing. There can be no doubt that wash is a rehearsal for watercolor painting.

So let us begin by defining this technique. We might say that:

The main characteristic of wash consists of drawing and painting with just one or two colors diluted with more or less water, and of obtaining the values in the subject with the help of the white of the paper, that is, by means of color transparencies, or glazes.

The term *glaze* in painting means the application of a layer of transparent color, whether directly onto the surface, in this case the paper, or on top of another color, to create a particular color or value or to strengthen a shade that is already there.

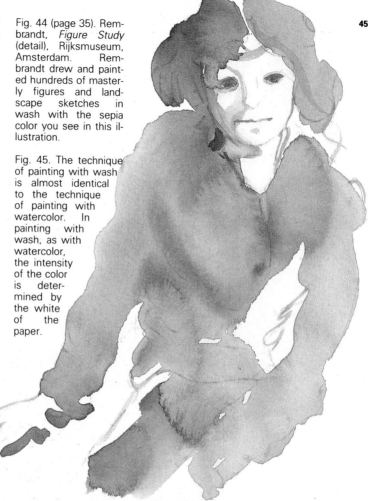

Fig. 44 (page 35). Rembrandt, *Figure Study* (detail), Rijksmuseum, Amsterdam. Rembrandt drew and painted hundreds of masterly figures and landscape sketches in wash with the sepia color you see in this illustration.

Fig. 45. The technique of painting with wash is almost identical to the technique of painting with watercolor. In painting with wash, as with watercolor, the intensity of the color is determined by the white of the paper.

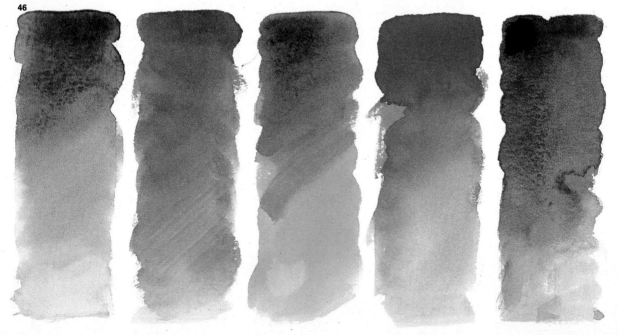

Techniques and skills

We already know that wash is done with one or two colors, with occasional help from black. As these colors come out of the tube, they are opaque; they cover. To develop them, to obtain the whole range of values from the darkest to the white of the paper, they must be diluted with water. The more water, the less color; the more water, the more transparency. The more water, the more the white of the paper acts; the more we see the white of the paper, the lighter, therefore, the value is of the color.

There is no rule that says which colors are the most suitable for painting with wash, but there seems to be a marked preference for dark colors, such as sea blue, sap green or emerald green, or a sienna or burnt umber. According to the subject, however, lighter colors, such as ultramarine or cobalt or even an ochre, may be more appropriate. In any case, it is possible to mix the colors with black or to combine two colors together, such as cobalt blue and burnt umber; complemented with black or

the white of the paper, they can give an almost complete—or at least very broad—range of colors, as we can see in figure 46.

Wash painting in the purest sense excludes retouching or repainting with opaque white. In other words:

In wash painting, as in watercolor painting, the whites must be obtained by deliberately reserving the white of the paper.

This said, it is easy to deduce that to paint a middle-value, even, uniform tone we need to use the white of the paper, diluting a little watercolor with a certain amount of water and totally dissolving the pigment of the watercolor to obtain a kind of ink wash. We are going to practice doing this, painting right now with a single color a uniform value and a gradation. It has been rightly said that the person who can paint a uniform value or gradation with a single color may say that he knows how paint with watercolor.

Fig. 46 (opposite page). For painting with wash, intense colors like the ones in this illustration are commonly used.

Fig. 47. See in the sample below the broad range of colors and values that can be obtained by wash painting with only two colors: *cobalt blue and burnt umber.*

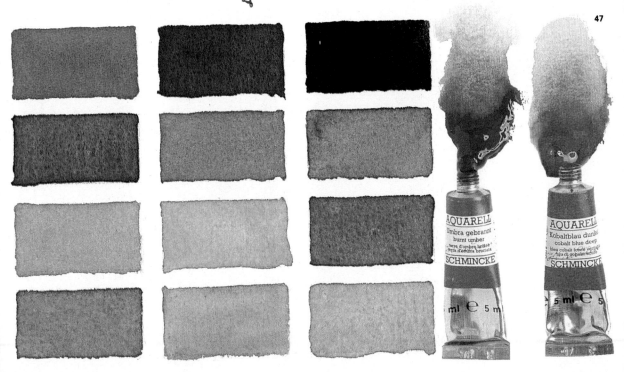

How to paint an even, uniform value

THESE ARE THE MATERIALS:
A jar for water
A pan or small dish
Medium-grain drawing paper
A scrap of paper for testing colors
and using as a palette
Cobalt blue watercolor
One or two brushes (numbers 6 and
12)
A roll of paper towels
A drawing board
Drawing pins

Fix the drawing paper to the board with drawing pins. Using the pencil, draw a frame about 13 cm wide and 12 cm high (5 × 4 3/4 in.) on the paper, and . . .

49

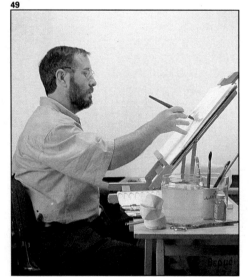

50

Put cobalt blue watercolor in a pan or small dish or saucer. Take a number 12 brush, wet it, and take it out of the water still dripping. Carry this load of water to the pan and repeat the operation again and again. Now pick up a little color with the brush; dip it in the water; stir it until the watercolor is totally dissolved with the water.

But wait a moment. Before painting this light blue tone, we have to control the intensity.

How? Load the brush, squeeze it, and paint a little on a separate piece of paper, on the scrap you are keeping for tests, trying out the intensity of this blue color. This is where the "palette" —your scrap of paper—comes into operation (fig. 48).

Figure 49 — Paint with the board sloping at an angle of about 30 degrees.
Figure 50 — Load the brush again, but this time do not squeeze it; take it to the final paper well loaded and . . . paint a horizontal strip about 2 cm (3/4 in.) wide.
From left to right, with a bold continuous brushstroke, like the line you draw with a pencil.
Figure 51 — Paint a new strip below, keeping the accumulation of color formed on the lower edge (A). Paint

48

Fig. 48. Many watercolor professionals keep a scrap of paper at hand —sometimes they use the white margin of the picture itself—where they can try out a color before painting.

Fig. 49. This image shows the correct position for the artist while painting with watercolor and the slope of the board, in this case provided by a tabletop easel.

Fig. 50. To paint a wash, a background or a sky, in a uniform color, begin at the top with a strip of color from one side to the other.

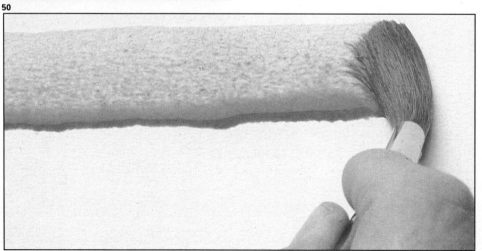

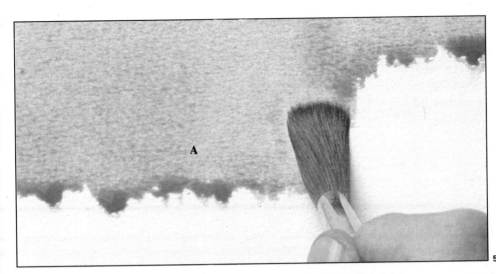

Fig. 51. With the drawing board at a slope, continue with vertical brushstrokes, which carry and accumulate the wash . . .

Fig. 52. . . . and the excess color wash will be absorbed by the brush, which you have squeezed out.

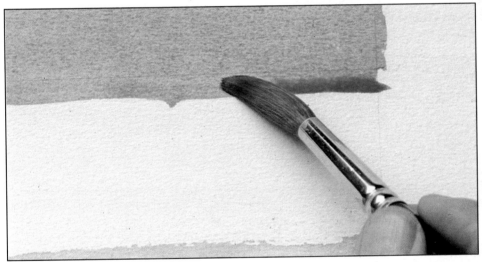

another strip below those previous ones and another . . . and another . . . and so on until the end. But . . .

Figure 52 — . . . when you reach the lower edge of the frame, you will find yourself with an excess of color that has to be eliminated. Nothing could be easier. Clean the brush with water, dry it with a paper towel, squeezing the water out, and immediately apply the tip of the brush to the color that has accumulated on the lower edge of the gray and . . . there you are! The brush acts like a sponge and soaks up all or part of the excess wash. Now here are two important deductions to be made from this exercise, which I feel I should emphasize:

In wash, as in watercolor, the painting is generally done from TOP TO BOTTOM.

The direction of the brushstroke most commonly used is VERTICAL.

How to remove color from a freshly painted area

Talking about the accumulation of color in the final phase of the previous shading and how to soak up the excess reminds me to tell you about one of the most widely used tricks of the trade in the technique of wash. I am referring to the system frequently used by professional artists to modify a tone, to make it even, to bring it down or gradate it, to rectify it as they go, that is, to go back over the painting, polishing it and, in the process, strengthening and lightening, which is so typical of the art of modeling, of painting the volume of forms.

On the blue shading of the previous exercise, apply the wet brush and deposit clean water on a particular area. Allow this water to soak into the paper, adding more water if necessary. Stir the color in the area to break up the blue paint. Then wash the brush and squeeze it with a paper towel. Finally, repeat the process with a sponge lifting the color, cleaning once again with clean water, squeezing again with paper towels, soaking up again, and so on. In this way you will manage to bring down the blue color almost to the white of the paper.

There is more. If you want to obtain an absolute white with this lifting trick, you only have to prolong the operation and finally moisten with bleach diluted with water (a 20 percent solution) and then work with a synthetic brush, since sable hair will not stand up to the action of the bleach.

Fig. 53. To modify a value or a color, to make it even, bring it down, or gradate it, or even to eliminate it, recovering the white of the paper, it is normal to use the brush as a means of lifting color. With recently painted color and with the brush clean and squeezed dry, the sheaf of hairs applied to the wet area acts exactly like a sponge and lifts the color (A). For the color to be removed totally, you can use a solution of water and about 20 percent bleach (B).

53

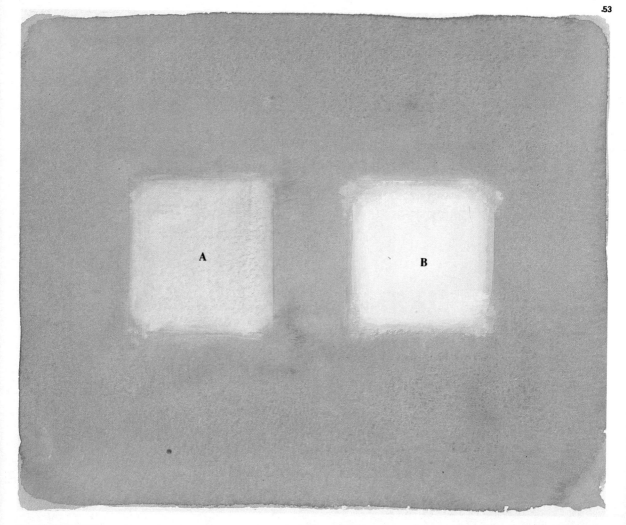

Wet painting of skies: beware of cuts!

First we must understand that what we mean by the painting of skies is the painting of broad areas that correspond to the sky in a landscape. By analogy we apply this term to the painting of any broad shading where there are light tonal variations, gradations with very slight contrast, and even broad areas of uniform value. In these cases it is usual for the artist to paint with the *technique of wet-on-wet watercolor*, previously wetting the sky area with clean water. Here is the procedure:

The area to be shaded is marked out with fine pencil lines. It is then wet with clean water, using a clean brush, a *Japanese-type broad-ended brush*, or a small sponge. It is very important for

this moistening to be even, controlling and spreading the "loads" of clean water to obtain a uniform wetness, and to prevent pools of water from forming. Then you go on to the tinting of the area, painting with color already prepared and following the procedure explained previously, but with the chance to accentuate or intensify the color at particular points, to break up the uniformity of the tone.

But beware! The moisture must be maintained to avoid "cuts." When the area is left half-painted, is painted with too little liquid, or is not painted quickly enough in the shadings and gradations, what we call a *cut* appears—a sharp jump in tone, which breaks or cuts the continuity (fig. 54 A).

Fig. 54. To paint a background, a sky, or a broad gradation, it is usual to employ the wet-on-wet technique, wetting the paper with water using a sponge or a broad-ended brush and immediately applying uniform color to the wet paper. Here, and in all backgrounds or skies, you have to work with sureness and speed to prevent the color wash from drying and producing *color cuts* (54 A).

54

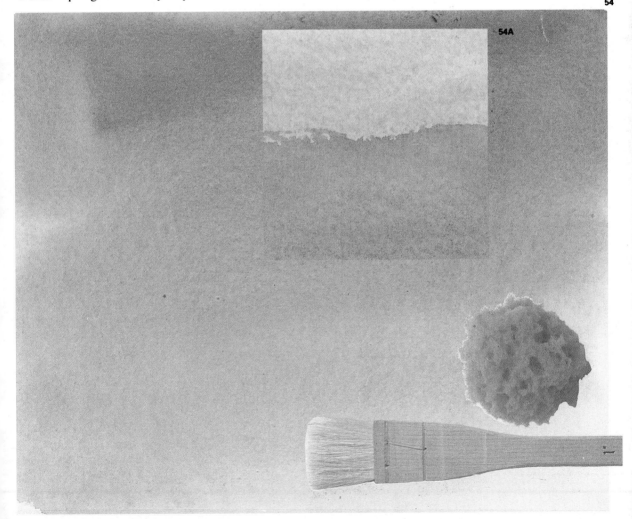

54A

How to paint a gradated wash

Let us begin by painting a dark color at the beginning of the gradation.

As quickly as possible we will clean the brush in clean water and wet all the areas to be graded . . . (fig 55 A).

Figure 55 B — . . . until we reach the edge of the original dark color. It is important for the paint to be still moist in order to dilute it, extending and grading with fast vertical brushstrokes. Ah, but wait!

Figure 55 C — Clean the brush again. Dry it and squeeze it with a paper towel and carry it to the middle of the gradation, removing water and color from this edge area.

Figure 55 D — Clean the brush again. Squeeze it again . . . and once again spread the color toward the area that is still white . . . retouch and harmonize the previous area . . .

It is a question of spreading and bringing down the color, of adding water and harmonizing by gradation, bearing in mind that this is always possible *provided that the moisture remains (to avoid cuts) and that the dark parts do not invade the light ones.*

If shading or gradating with watercolor is something new for you, you are unlikely to be successful at your first attempt. Of all the painting processes, wash and watercolor painting are the ones that most require an apprenticeship, a practical knowledge to master the medium and its technique. So don't worry if it doesn't come out the first or the second time. Keep trying, and remember the phrase that says: "Success is the story of our failures."

Fig. 55. Gradating a color with a brush always requires solution in water and later blending with a more or less heavily loaded and more or less wet brush to add or lift color, as may be seen in the illustrations.

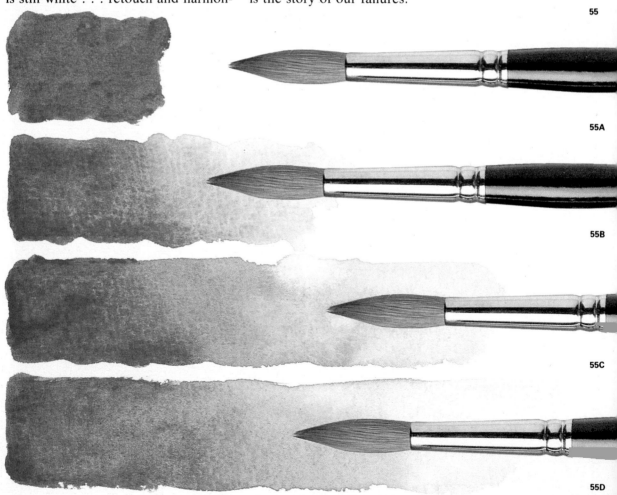

55

55A

55B

55C

55D

Superimposition of layers or glazes

When painting with wash or painting with watercolor, it is usual to superimpose layers to intensify the values, to adjust the modeling, to create contrast. For example, to paint the shape and volume of a cube, the color of each face must be painted directly, but it is also valid to do it by superimposing glazes in the following manner:

Figure 56 — First paint all the areas in shadow with a glaze of the same value.

Figure 57 — Wait until it dries and apply a new layer or glaze on the darkest plane.

Figure 58 — To finish the cube, paint a strip of light color on the upper face . . .

Figure 59 — . . . quickly gradating while it is still wet, applying the brush with clean water, diluting, blending...

The only thing to bear in mind for painting one tone on another is the need for the first one to be completely dry. But beware! Don't run away with the idea that a good wash or a good watercolor can be obtained by superimposing many layers of color, raising the tone slowly, glaze on glaze, until you achieve the right intensity. No, not at all. This is exactly the opposite of what a good wash or a good watercolor should be. Let this be clearly understood:

The essential characteristic of a good wash or a good watercolor consists of painting the tones on the first attempt, with the fewest number of glazes possible.

Fig. 56 to 59. If you paint a cube like this one in a larger size (at least double), you will be carrying out a practical exercise on washes, background, glazing, and gradating. It is undoubtedly interesting as a practical application of the lessons about painting with wash in this book, which can also be applied to painting with watercolor.

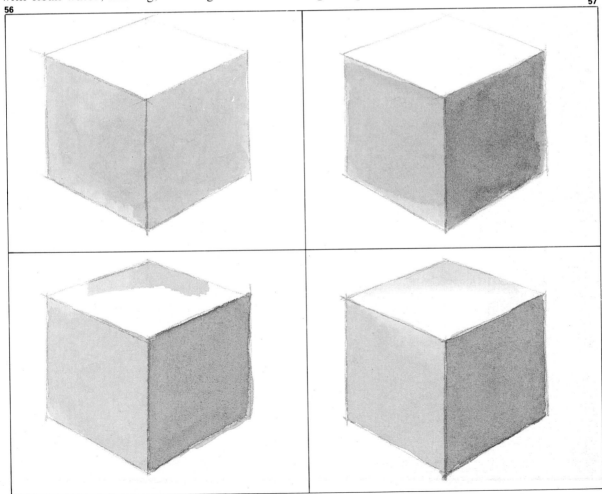

56

57

58

59

This ends the first lesson: shading, gradating, lifting color, and avoiding *cuts*, all applied finally to the exercise of painting a cube. The next lesson is more advanced; we might almost say definitive. Among other things, it is about painting a cylinder and a sphere and ends with a real subject, a horse's head. Perhaps the most difficult of all these exercises is painting a sphere; be warned. So you should paint several cubes, several cylinders, and plenty of spheres before practicing with the last of these exercises, the horse's head. This subject, like all subjects from a tree to a human body, basically consists of cylinders, spheres, and cubes; and if you can paint the circular gradation of a sphere with the whole play of light and shadow, highlights and reflections, you will have no problem painting fruit, a face, a mountain, or a flower.

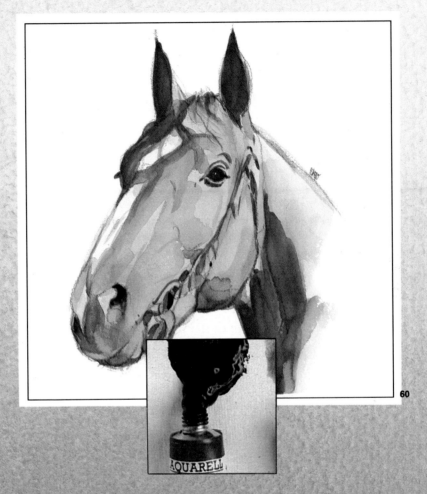

60

PRACTICE EXERCISES
—IN PAINTING—
WITH WASH

Painting a book with two colors

So that you can consolidate these lessons, there follow a series of practice exercises in wash painting, which you can use to make your debut with this medium.

In the series of forms or models presented below, we have tried to summarize all the technical difficulties of both wash and watercolor so that, once you have perfected these exercises, we might say that you will be in a position to paint any subject, however complicated it may be.

First and foremost, good construction. You might even look carefully at a real book and, if necessary, use a ruler and triangle to calculate the position of the horizon line and the vanishing points and so on.

Then start by painting the spine (A) and the corners of the covers (B and C) in crimson. Wait until the crimson dries and continue painting the plane with Payne's gray (in a light tone). Note that you have to reserve this point of light at edge *a* (fig. 62).

The next step consists of painting plane D, the cover of the book, reserving the frame for the title.

Once the whole plane is wet, give it one brushstroke of crimson wash in the most distant part. Then clean the brush and spread this brushstroke downward, gradating (fig. 63).

Now strengthen corners B and C and plane A, which corresponds to the spine of the book, painting a new glaze or layer in the same color as before (perhaps a little more intense), to give a darker value. With the same Payne's gray, paint the shape of the projected shadow, gradating its outer edges (fig. 64).

Finally try to obtain the gradation in the darker part of the shadow of the spine. To understand the procedure, look at figure 64 and the image of the finished book in figure 65. Bear in mind that you first have to paint a dark strip and then, while it is still wet, gradate it, lifting and blending until you achieve the result in figure 65.

For this or any other similar operation to be successful, *it is vital to let the previous layer dry before working on top with another*. To finish off the exercise, strengthen the area marked *b* with a dark line and paint the title of the book with a single brushstroke.

61

Fig. 61. This exercise can be done with the two colors reproduced here: crimson and Payne's gray.

62

Fig. 62. Using a line drawing with the correct perspective, begin by painting the spine and the corners of the covers in crimson, reserving the small effect of light marked *a*. Wait until the crimson dries, then paint the corner of the pages of the book with Payne's gray.

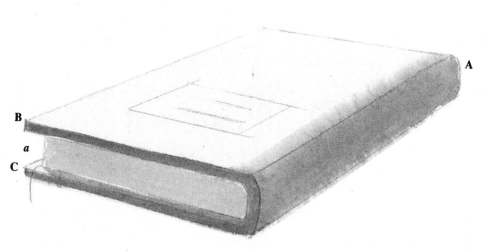

63

Fig. 63. With the same crimson color, paint the cover of the book, reserving the white frame of the title; once this first layer is dry, build up a gradation from the farthest corner of the cover.

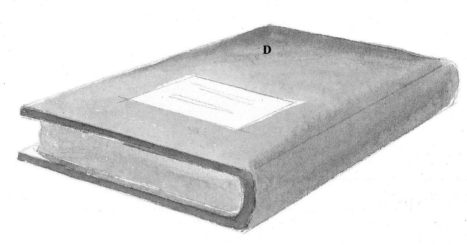

64

Fig. 64. Now you have to strengthen the color of the spine and the corners of the cover; once the crimson wash has dried, paint the projected shadow of the book with Payne's gray.

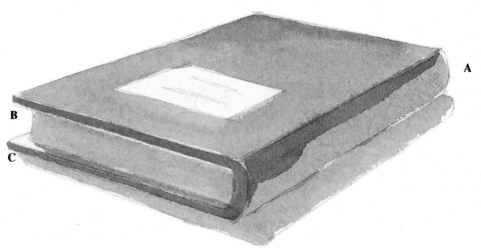

65

Fig. 65. Finally, strengthen the areas and colors in shadow as you see fit, such as the darkest part of the spine of the book; then paint the typographic representation of the title with simple lines.

Painting a sphere with wash

First draw the sphere with an HB pencil and with the help of a compass, if you like. Mark the form that corresponds to the highlight of the sphere with a small circle (A); then draw the projected shadow (B); with just a little water, moisten the whole sphere except the circle that corresponds to the highlight. Painting wet-on-wet, apply a first layer of color in a very light tone to the whole sphere, reserving the white of the highlight and trying to gradate and fuse this white with the general light tone of the sphere. Still working wet-on-wet, paint the area of color corresponding to the projected shadow (fig. 66).

Quickly now! Remove the color from the brush without cleaning it, just wiping it on a rag or paper towel, and, still working wet-on-wet, dilute the previous color and gradate it spherically. Wait until the whole sphere is dry, then wet the form corresponding to the projected shadow (C) with just a little water. Paint the form, using the wetness to gradate its edges (fig. 67).

Finally, wait until the whole figure is dry and, if you feel you should, strengthen the intensity of the shadows, always working wet-on-wet and never losing sight of the process explained so far (fig. 68).

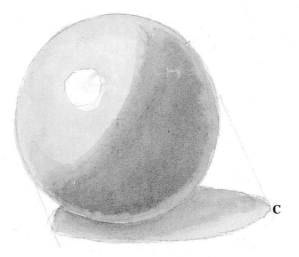

66

67

Figs. 66 to 68. "You learn to draw by drawing," or, which comes to the same thing, "you learn to paint by painting." The text and illustrations on this page explain in minute detail, step-by-step, how to paint a sphere; but unless you practice this exercise over and over again, you will never master the technique of painting a sphere with wash.

Figs. 69 to 71. Apply what was said in the text above about how to paint a sphere to this exercise. On a separate piece of paper, practice painting shadings, gradations, and the effects of light and shadow on cylindrical, cubic, and spherical forms in order to acquire, from these preliminary exercises, the experience that will enable you to paint the volume or modeling of any form.

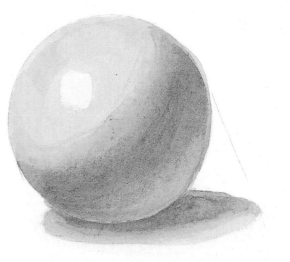

68

Painting a cylinder and a cube with two colors

First paint faces A and B of the cube and the shadow thrown by it with very diluted emerald green. Gradate the edges of the shadow. Moisten the illuminated side of the cylinder with clean water and paint the shadow of the cylinder wet-on-wet (fig. 69).

Intensify face B of the cube with another layer of color and, when this face has dried, paint the smooth gradation of face A and the gradation of the upper plane of the cylinder (D) in the same style. When the whole is completely dry, repeat the moistening operation with just a little water on the whole cylinder and strengthen the part corresponding to the shadow, beginning with an intense stain from top to bottom (fig. 70); continue with the gradation toward the right side, lifting color when you reach the edge in order to represent the reflected light of this zone. Once this gradation has dried, finish the exercise by painting the shadows thrown by the cylinder (fig. 71).

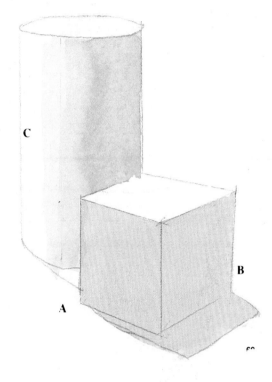

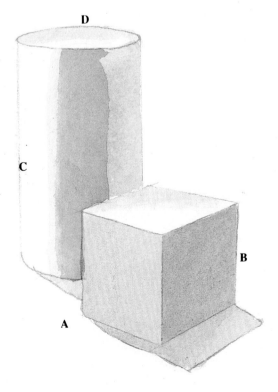

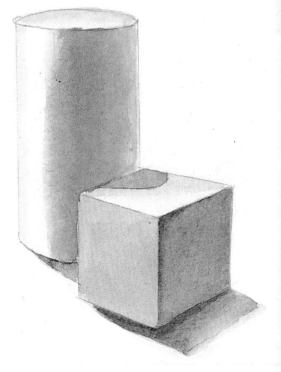

70

71

Painting a horse's head with wash in one color

Now we are going to reproduce a horse's head, painting with wash and using the model illustrated in figure 72 as a reference. To do this final exercise, we are going to paint in a single color, raw umber, so as to avoid the problems of color and devote our whole attention to the techniques of washes and gradations, which present identical difficulties to painting with watercolor.

Let's go:

Preliminary drawing

As usual, you must begin with a very careful drawing, bearing in mind that the final result depends to a great extent on whether or not you do this drawing correctly. You can use the well-known system—frequently used even by professionals—of making a grid for the model and then transferring this grid, in the same size or larger, whatever you feel suitable, onto the drawing paper. Last, and forgive me for insisting, what you are basically interested in is an absolutely correct, clean first drawing (fig. 73).

Fig. 73. The preliminary drawing for painting with wash or watercolor must always be linear, without shadows, with the fewest possible lines. Bear in mind that true painting demands that the edges of forms be defined by tone or color, not by line, and that, moreover, the effects of light and shadow be painted exclusively with the colors, with no shading done in lead pencil.

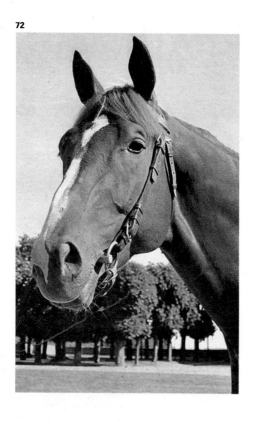

72

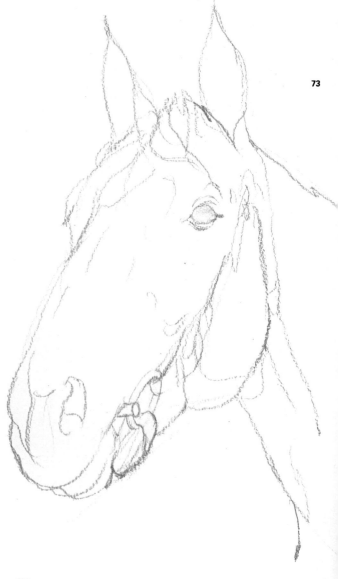

73

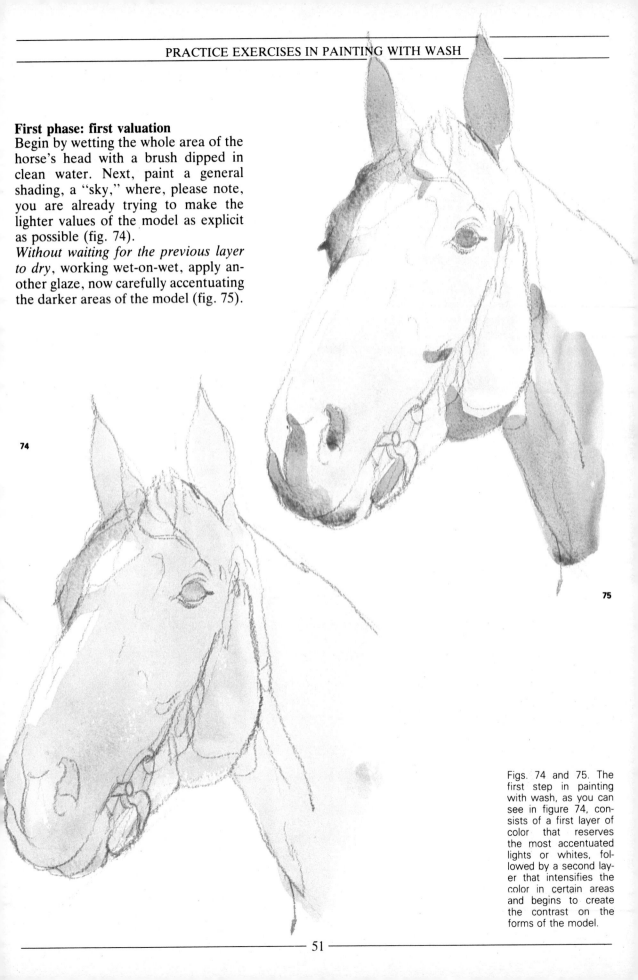

First phase: first valuation

Begin by wetting the whole area of the horse's head with a brush dipped in clean water. Next, paint a general shading, a "sky," where, please note, you are already trying to make the lighter values of the model as explicit as possible (fig. 74).

Without waiting for the previous layer to dry, working wet-on-wet, apply another glaze, now carefully accentuating the darker areas of the model (fig. 75).

74

75

Figs. 74 and 75. The first step in painting with wash, as you can see in figure 74, consists of a first layer of color that reserves the most accentuated lights or whites, followed by a second layer that intensifies the color in certain areas and begins to create the contrast on the forms of the model.

Painting a horse's head with wash in one color

Now wait for the previous layers to dry completely and work more depth into the modeling, until you produce the result illustrated in figure 76.

Second phase: final valuation
Still working on dry or wet areas, according to need, and applying all the knowledge you have acquired up to now about shadows and gradations, keep adding values, intensifying tonalities, until you achieve the almost final stage illustrated in figure 77.

Third phase: the finishing touch
In figure 78 you can see the final state of the work. Remember that this final version is the result of patient, calculated, unhurried work, the product of constant comparisons between the work and the model.

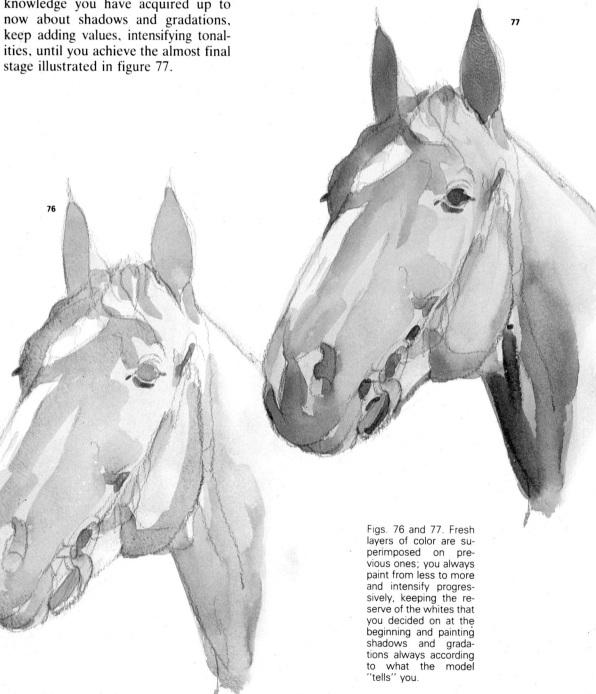

Figs. 76 and 77. Fresh layers of color are superimposed on previous ones; you always paint from less to more and intensify progressively, keeping the reserve of the whites that you decided on at the beginning and painting shadows and gradations always according to what the model "tells" you.

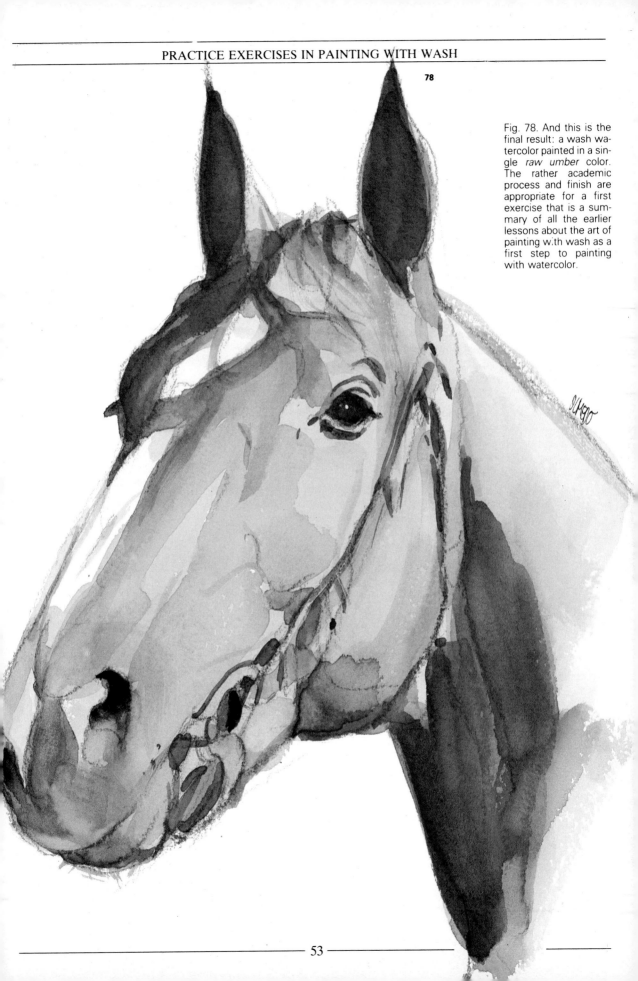

78

Fig. 78. And this is the final result: a wash watercolor painted in a single *raw umber* color. The rather academic process and finish are appropriate for a first exercise that is a summary of all the earlier lessons about the art of painting with wash as a first step to painting with watercolor.

Now that you have passed your examination in painting with wash, you can go on to take your higher degree in painting with watercolor. The program will consist first of discovering the possibilities of this medium in terms of subject matter and forms of artistic expression in general; we shall then go on to technique, that is, the forms, languages, and textures that can be achieved by painting with watercolor. Next we enter into the study of colors and mixtures, first painting with only three colors and black. Then practical exercises, with pictures painted by Guillermo Fresquet, are explained and illustrated step-by-step until we reach the exercise for the final examination, which we hope you will do as proof that you know how to paint with watercolor.

79

TECHNIQUES
—AND SKILLS—
OF WATERCOLOR
PAINTING

Possibilities of watercolor painting

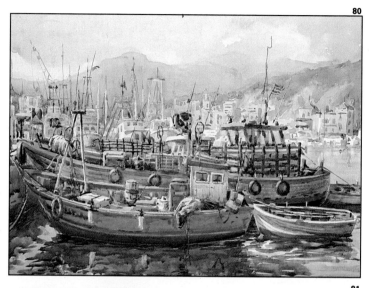
80

Considered as an artistic medium, watercolor need take second place only to the king of paints: oil. Its possibilities are almost unlimited as far as subject matter is concerned; in museums and famous collections all over the world there are watercolor paintings of landscapes, figures, portraits, and still lifes. However, there is no doubt that among the most suitable subjects are landscapes, both country and city, and seascapes.

Watercolor is also an ideal medium for planning and making studies of large paintings or murals to be painted later in oil, tempera, or fresco.

We should also mention the usefulness of watercolor as a medium frequently used in architecture and interior decoration for planning and drawing perspectives of buildings and interiors. And finally, watercolor is the medium generally used in the field of illustration, particularly in the illustration of children's books.

81

Figs. 80 to 83. The artistic possibilities of watercolor painting are unlimited; all subjects, all themes, especially country landscapes, seascapes, and cityscapes, but also figures and even portraits, as demonstrated by these watercolors by Fresquet (figs. 80 and 81). Watercolor is also an ideal medium for creating illustrations such as these by María Rius and Agustín Asensio in children's books published in Spain by Parramón Ediciones. The graphic artist in advertising, the designer, and the architect also use watercolor as a medium of artistic or technical expression.

82

83

Basic techniques of watercolor

The most important characteristic of watercolor painting is the transparency of its colors when diluted with larger or smaller amounts of water and applied to the white of the paper. A small amount of red with a large amount of water will cause the paper to reflect plenty of white light and give a pale pink color. By increasing the amount of red, the transparency will be less, the white of the paper will be less visible and the result will be a deeper pink color. This characteristic—transparency—conditions the technique of watercolor in three basic ways:

1. **When painting with watercolor, you cannot superimpose a light color on a dark color.**
2. **When painting with watercolor, you must go "from less to more."**
3. **When painting with watercolor, you must reserve the whites and light colors beforehand.**

If there is a little white house surrounded by trees and bushes in the landscape we are painting, we must first paint the green of the grass and the trees. If there is a pale umber-colored road beside the house, we must first paint the light sienna color of the road itself—or afterward, but in this case we must reserve the form of the road—and superimpose the dark sienna that will mark the edges; that is, we go "from less to more," with the possibility of applying another layer.

But it is not all difficulties. This possibility of intensifying tones by applying fresh layers of color also allows us, in certain cases, to modify and tone colors, as you can see in figure 86.

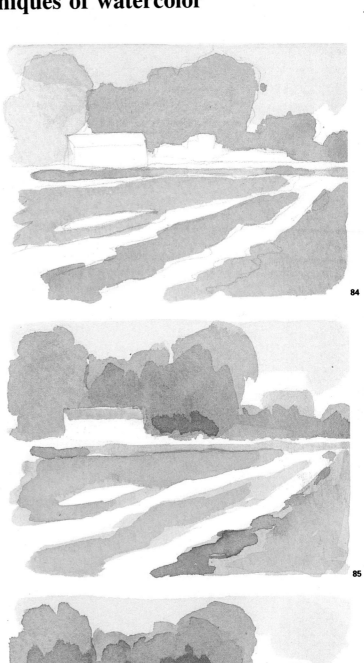

84

85

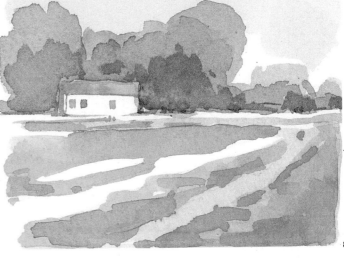

86

Figs. 84 to 86. Basic watercolor techniques; it is not possible to paint a light color over a dark one; you must always paint from less to more and reserve the whites and light colors beforehand.

Special techniques of watercolor

A good watercolorist shows his skill in reserving whites. But this reserving can also be done by other means:

Opening whites by lifting. This is just a matter of "sucking up" the recently painted color, lifting it with a squeezed brush (fig. 87 A).

Reserving whites with wax. If you draw a line or a stain with white wax and then paint with watercolor on top of the wax, you will obtain a reserve of white because the wax will repel the water (fig. 87 B).

Reserving whites with liquid gum. This is the safest and most drastic process: it consists of painting the areas or lines to be reserved with *liquid gum*, a common product in art-supply stores. When this reserve is done, you can

Fig. 87. Here is a graphic example of special techniques applied to watercolor painting; from left to right, opening whites with the squeezed brush, lifting color (A); reserving whites with lines of wax that repels the color or wash (B); reserving whites with *liquid gum*, the most efficent system (C); opening whites, or rather light lines, on a dark background with the beveled tip of a brush handle or with a fingernail, drawing on a recently painted area that is still wet (D). And finally, creating a special texture or finish by means of table salt sprinkled on a recently painted area (E).

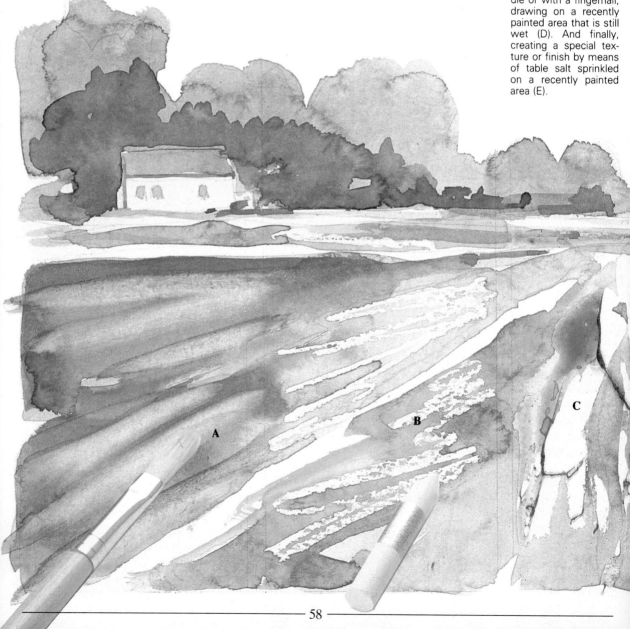

paint on top and around and later eliminate the liquid gum when the watercolor is dry. You will automatically obtain a perfect reserve of whites.

Opening whites with the tip of a brush handle or with a fingernail. When the watercolor paint has almost dried, you can draw on it with the tip of a brush handle "or with the fingernail"—as Fresquet says and does—to obtain lines of light color suitable for representing light, slender forms on a dark background, such as small highlights, branches, grass, and so on.

Special texture with salt. This is an easy but remarkably effective formula that consists simply of sprinkling table salt on a freshly painted area while it is still wet. We can see then that, as the watercolor dries, the grains of salt soak up the pigment and create strange stains of light color. When the color wash has dried, you only have to rub gently with your fingers to take off the grains of salt, leaving behind a surprising texture.

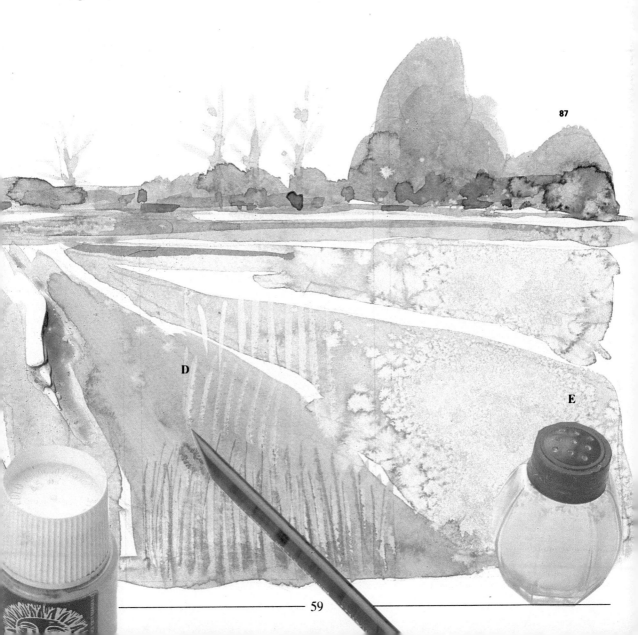

Wet watercolor

If you first wet the paper with clean water and then, without waiting for it to dry, paint a green meadow in the foreground and, still without waiting for it to dry completely, a range of blue hills in the background; if you continue to take advantage of the wetness and paint another darker green on top of the first one and a strip of trees and clumps of grass . . . if you go on with this technique, lifting water to mark out forms, adding color to others . . . you will be painting a wet watercolor, achieving a special style in which the forms are atmospheric, with no well-defined lines, especially in the distant outlines and volumes (figure 88). (The effects of wet watercolor are particularly applicable to low-contrast subjects such as gray, sunless landscapes, cloudy scenes, or rainy days. The technique of wet watercolor is generally suitable for representing distant grounds, skies, and backgrounds, even when the subject is contrasted, for example, in a landscape in strong sunlight.)

Fig. 88. *Wet* watercolor: a technique of painting *wet-on-wet*, that is, applying color to an area moistened beforehand with water or to another color that is still wet, achieving a finish with ethereal, diffuse forms such as the ones you can see in this illustration.

88

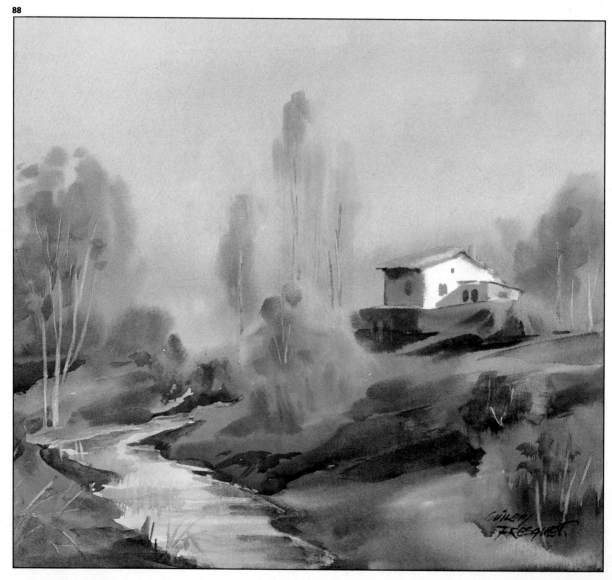

Speed of execution

In watercolor painting there is no such thing as a picture done in several sessions, at least not in watercolor as it is understood today.

According to all modern artists and theories, watercolor must be understood to be an impression painting, a work that captures the landscape at a given moment, with just time to paint "that sun, those colors, those effects of light and shadow." Painting a landscape with watercolor should not take more than three hours. A quick sketch requires half an hour, and a thumbnail sketch can be done in ten minutes or a quarter of an hour.

89

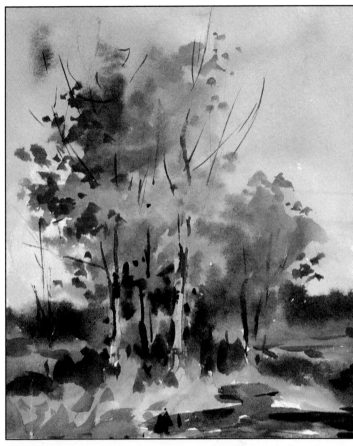

90

Figs. 89 to 91. The technique of watercolor demands rapid execution, almost always painting *alla prima*, or first time, with no retouching, no regrets. And so we can talk about short or maximum times, calculating approximately ten minutes for a thumbnail sketch, half an hour for a quick sketch, and three hours, four at the outside, for a watercolor, a finished picture.

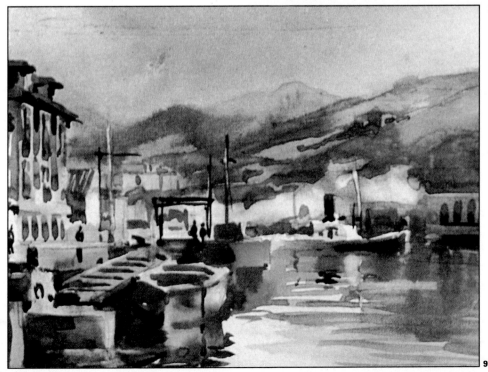

91

I suppose you are familiar with the phenomenon of the theory of colors; the fact that with just 3 colors mixed together, blue, crimson, and yellow, all the colors of nature can be reproduced. Now we are going to study how to obtain 64 different colors with a mixture of the 3 colors mentioned and the help of black. It goes without saying that the number of possible colors is not restricted to 64. In theory and in practice, it is infinite. A proof of this is the landscape you can see on the following page, in which Fresquet has achieved a wide range of colors and shades *painting with only the three primary colors and black*.

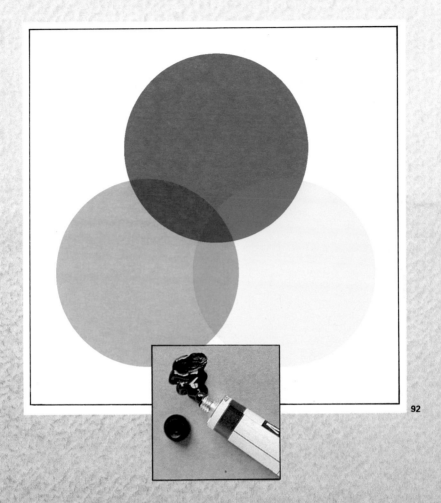

PAINTING
—WITH THREE—
PRIMARY COLORS
AND BLACK

Blue, crimson, yellow, and black

As you know, mixing the 3 primary colors in pairs yields 3 new colors, which are called secondary. These, in turn, mixed with the primaries give us 6 tertiary colors. When the primaries and secondaries are mixed with the tertiaries, 12 quaternaries are obtained, and so on and on to an infinite range of colors (fig. 95).

In the illustration you can see a landscape painted in watercolor by Fresquet using the three primary colors. blue, crimson, and yellow, with the addition of the white of the paper to lighten colors and with the additional help of black in some darker colors.

94

93

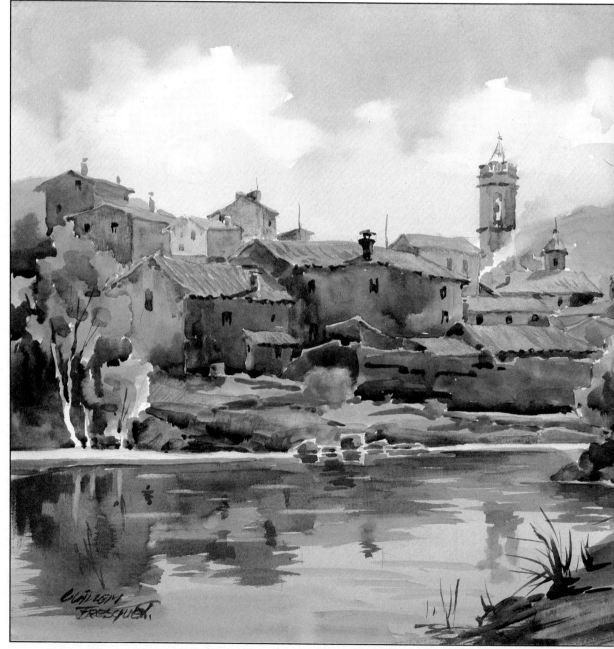

With only the three primary colors
**CYAN BLUE (OR PRUSSIAN BLUE)
CRIMSON (OR MAGENTA)
YELLOW**
it is possible to obtain all the
colors of nature, including black
(fig. 93).

**PRIMARIES WITH PRIMARIES
= SECONDARIES:**
crimson + yellow = red
yellow + cyan blue = green
cyan blue + crimson = dark violet
blue

**PRIMARIES WITH SECONDARIES
= TERTIARIES:**
yellow + green = light green
green + cyan blue = emerald green
dark blue + cyan blue = ultramarine
dark blue + crimson = violet
crimson + red = scarlet
red + yellow = orange

Figs. 93 to 95. Guiller-mo Fresquet shows us a magnificent example of the reality of painting all the colors of nature with only the three pri-maries, in this case, *Prussian blue, crimson,* and *yellow,* with the help of black on occa-sion, but in very few cases.

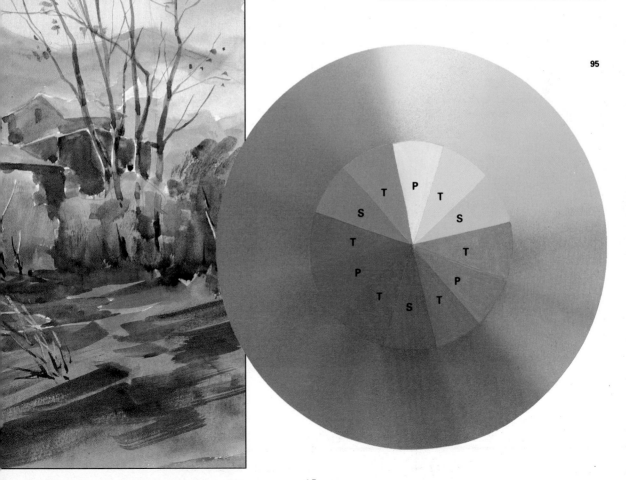

95

First practice exercise

Guillermo Fresquet is here with you and with me.

"Whenever you're ready, Parramón, we can start."
"All right. First, I think that it is very interesting to learn to compose all the tones and colors working with just the three primaries."
"With a little help from the black, of course."
"Yes, of course, Look: while you paint, I'll watch, take notes, and explain everything you do point by point, OK?"
"OK."

This is the plan: Fresquet will paint with watercolor while I, Parramón, will explain what he does and how he does it, commenting on some particular aspect from time to time with him. And you can follow these explanations in practice by painting and using the same process, following his instructions.

With only three colors . . . and black
Fresquet will start by working with only three colors, the three primaries, with the additional help of black. In your box of watercolors the three primaries are:

Ultramarine (or Prussian blue if you have the color in your box)
Crimson
Lemon yellow (or medium cadmium yellow)

Well, are you ready?
On pages 68 and 69 you can see the color chart we shall be using for this exercise. It contains 36 different colors, all obtained with the 3 primary colors and black.
With a fairly hard pencil, start by drawing *very lightly* on your drawing paper the boxes you will need to compose the colors of the chart.
Using the technique with which you are now familiar, start by painting the simple gradations of the three primaries, lemon yellow, crimson, and ultramarine, plus the black, as shown on the left-hand side of the chart (page 68).

Now paint the color chart following the usual order, from left to right. This is what you must do in each case to obtain the color you want:

1. **Read the reference for the colors appearing in each case according to the lessons below.**
2. **Compose the color, making the appropriate mixtures in the cavities of the watercolor box.**
3. **Try out the shade you obtain on a scrap of paper.**
4. **Paint the final color.**

In the event of a mistake, it is always preferable to "underdo it," leaving the opportunity to intensify and adjust the color.

Fig. 96. Guillermo Fresquet is going to do a practical exercise: to compose all tones and colors using only the three primaries and black. Our advice to you is to do the exercise yourself, because it is a very useful practice for learning to paint gradations and for exercising yourself in watercolor painting. So prepare the tools as Fresquet has done and follow the instructions in the text.

All colors with only three colors

This is the chart:

97

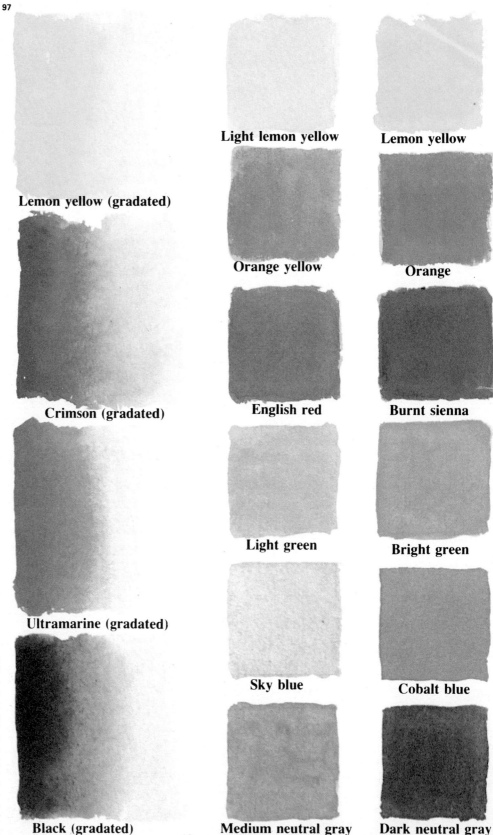

Lemon yellow (gradated)

Crimson (gradated)

Ultramarine (gradated)

Black (gradated)

Light lemon yellow

Lemon yellow

Orange yellow

Orange

English red

Burnt sienna

Light green

Bright green

Sky blue

Cobalt blue

Medium neutral gray

Dark neutral gray

Fig. 97. By mixing the 3 primary colors, *lemon yellow, crimson, and ultramarine*, and with the help of black Fresquet has composed these 36 different colors. By looking at this sample and following the instructions on the next pages, you can do this basic exercise, imperative for mastering the composition and mixture of colors.

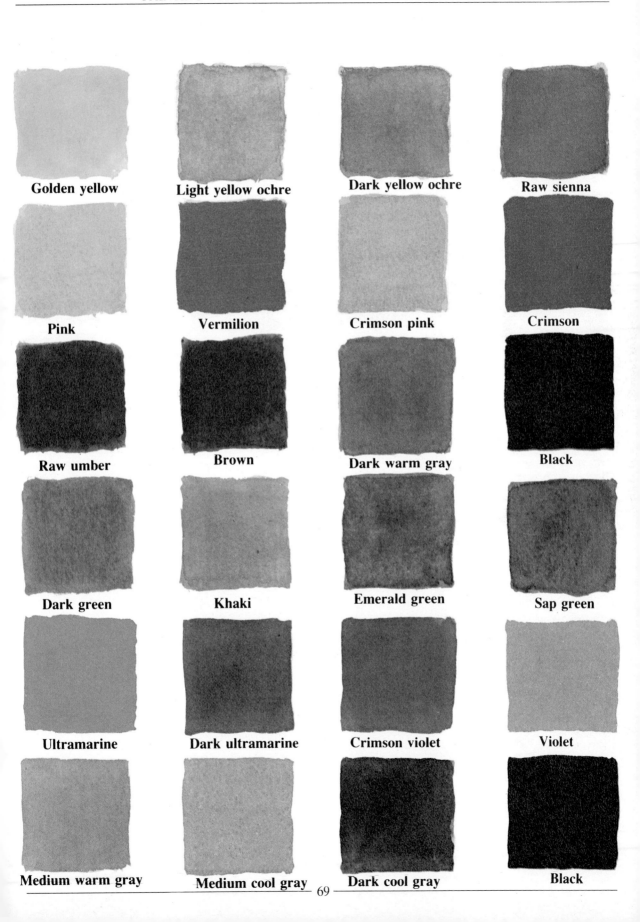

Golden yellow	**Light yellow ochre**	**Dark yellow ochre**	**Raw sienna**
Pink	**Vermilion**	**Crimson pink**	**Crimson**
Raw umber	**Brown**	**Dark warm gray**	**Black**
Dark green	**Khaki**	**Emerald green**	**Sap green**
Ultramarine	**Dark ultramarine**	**Crimson violet**	**Violet**
Medium warm gray	**Medium cool gray**	**Dark cool gray**	**Black**

All colors with only three colors

1. Light lemon yellow
Simply lemon yellow and water.

2. Lemon yellow
Slightly thickened yellow for greater intensity.

3. Gold yellow
First, intense yellow like the one before. Then add a very light crimson wash.

4. Light yellow ochre
Compose a gold yellow like the one before and, while it is still wet, add a touch of blue and black.

5. Dark yellow ochre
The same as the one before, but slightly increase the amount of crimson, blue, and black.

6. Raw sienna
Begin by mixing a gold yellow color and, while it is still wet, add crimson violet, the product of crimson and a little blue with plenty of water.

7. Orange yellow
Very dense, thick yellow with crimson applied while still wet.

8. Orange
Like the one before, but with more crimson.

9. Pink
Crimson diluted with water and a pinch of yellow.

10. Vermilion
Use a lot of thick, dense yellow, then add crimson, but without making it too intense.

11. Crimson pink
Crimson highly diluted with water and a touch of blue.

12. Crimson
First, a blue wash, then add intense crimson.

13. English red
Begin by mixing a fairly wet orange, then add a touch of blue to make it grayer.

14. Burnt sienna
Intense thick yellow and crimson. Then, while wet, add blue and black, with more black than blue.

15. Raw umber
First, mix a dark ochre, then go on to a raw sienna. Last, intensify with the three primaries and black if necessary.

16. Brown
Like the one before, but not so thick.

17. Dark warm gray
This color is a mixture of the three primary colors in almost equal parts that is applied to a dry layer of dark yellow ochre.

18. Black
Just as it comes from the pan, fairly thick so that it covers.

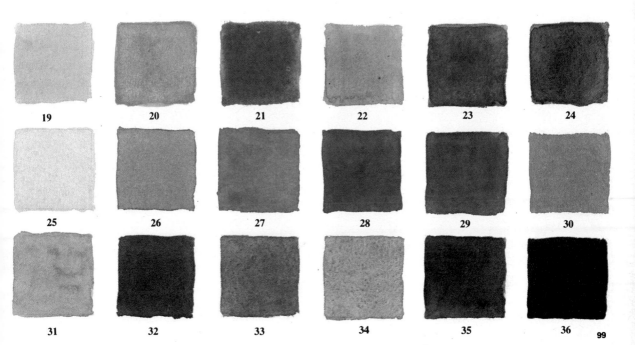

19. Light green
Rather intense yellow and a little blue.

20. Bright green
Like the one before, but with more blue.

21. Dark green
Like the one before, but with more blue and a little black.

22. Khaki
Begin by mixing a light green. Then, while still wet, add a little crimson and yellow. It may be necessary to finish with a pinch of black.

23. Emerald green
Yellow and a lot of blue, nothing else.

24. Sap green
Thick intense yellow, with a touch of black to make a dirty olive green. While still wet, add a touch of blue and there you are.

25. Sky blue
Blue diluted with a lot of water; then add a pinch of yellow while wet.

26. Cobalt blue
Intense but not thick blue, with a touch of yellow added.

27. Ultramarine
Just blue, not thick or dense.

28. Dark ultramarine
Thick blue and a touch of crimson and black.

29. Crimson violet
Blue and crimson with the crimson dominant.

30. Violet
A wash of blue and crimson.

31. Medium neutral gray
Paint white and black, both diluted with enough water for the white of the paper to show.

32. Dark neutral gray
The same as the one before, but with more black.

33. Medium warm gray
Paint black and white to obtain a medium gray. Then add (while still wet) a touch of blue.

34. Medium cool gray
First make a neutral gray, as above, and then, while it is still wet, add a little blue.

35. Dark cool gray
The same as the one before, but increase the amount of black and blue.

36. Black
Just as it comes from the pan, with enough density to cover.

Fresquet paints an apple

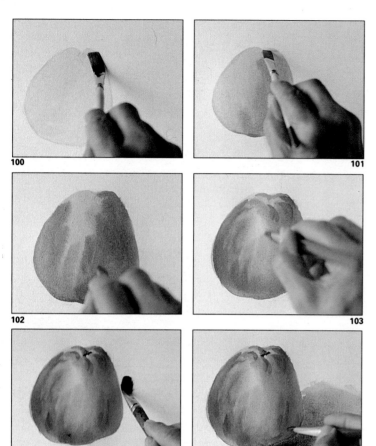

100

101

102

103

104

105

Fresquet is now going to paint an apple with the three primary colors and a little help from black. See the model in figure 106 at the foot of this page. He begins by making a quick sketch of the sphere of the apple with an HB pencil, a linear drawing with no shadows. Then, with a broad-edged brush, he wets the form of the apple with clean water and begins to paint. (See the process used in painting this apple in the photographs on the left and at the foot of this page, taken while Fresquet was painting the apple.) He paints the whole apple wet-on-wet with a rather dirty yellow and immediately dries the brush with a rag and lifts color from the left.

"Don't you use a paper towel to remove water and color from the brush?" I ask Fresquet.

"No, I usually do it with an old rag," he answers, and goes on: "I admit that paper towels work, but I have always cleaned and dried brushes with a scrap of old cloth."

While the yellow is still wet, Fresquet paints the left side with a few touches of crimson and a tiny bit of blue,

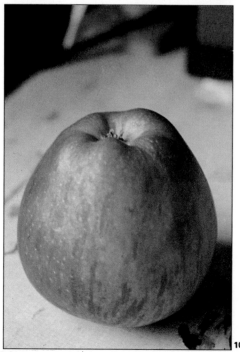

106

107

which, when mixed with the yellow, yield a dark sienna with which he starts to paint the colors of the apple in shadow.

He accentuates the crimson color and paints the red areas of the apple on the left side with brushstrokes from top to bottom.

Next, with blue and yellow he mixes a green whose luminosity is broken with a touch of crimson and an even smaller amount of black. The mixture is lightened with water, to make a dark, grayish ochre that he uses to paint the almost final version of the side in shadow, on the right (see this color in the second to last and last stages at the foot of this page, figures 108 and 109).

Fresquet paints with a broad brush, over 1 cm wide, a number 10 sable hair, which he sometimes uses flat and other times uses edgeways, according to whether the forms of the model require a broad stroke or a narrow stroke. But in his left hand Fresquet holds another brush with the sheaf of hair almost dry, without color, squeezed out, and occasionally after painting with color, he quickly changes

to the dry brush and passes it once or twice over the color, wet-on-wet, gradating and blending the color with the background or some other color. These are gentle touches, caresses, always wet-on-wet, which give the excellent qualities of form and color that you can see in the finished apple.

To paint the shadow thrown by the apple, Fresquet begins by wetting the oval shape, then paints immediately with a mixture of the three primary colors, which, with the help of black, yields the gray, which is painted dark next to the apple and made lighter on the edges through the lifting of color and the application of a larger quantity of water.

Before signing off, he lifts color from the right edge of the apple next to the part in darkest shadow to represent the reflected light on the model.

Of course, watching Fresquet paint is a show, which I hope is reflected in the sequence of *step-by-step* images that illustrate the painting of this apple.

Figs. 100 to 109. Using an apple placed in front of him as a model (fig. 106), Fresquet draws the outline of the apple and wets the spherical form with clean water (fig. 100). He loads the brush with yellow and, working wet-on-wet, paints the form of the apple, lifting color from the lighted side (fig. 101). He makes up a yellow ochre, combines it with crimson, and, still painting wet-on-wet, draws and paints the colors of the apple; he dilutes and blends the colors, "brushing" with a squeezed broad-ended brush (figs. 102 and 103). He has almost finished with the apple and wets the area corresponding to the shadow (fig. 104), next applying a dark gray color with a warm tendency. He finishes the apple by lightening and heightening the reflected light in the area in shadow (fig. 105). At the foot of the page, you can see in figures 107, 108, and 109 how the apple is painted step-by-step in three phases by Fresquet.

108

109

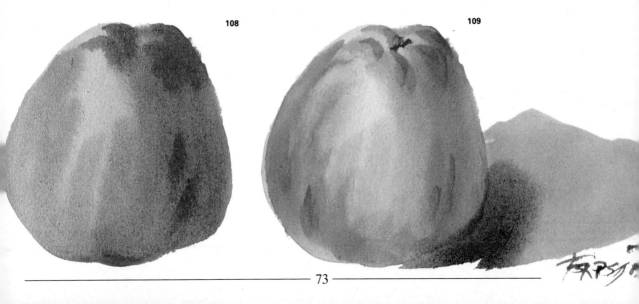

Now Guillermo Fresquet will paint four pictures, a still life and three landscapes, summarizing the lessons of the previous pages in these four subjects. First he will paint the still life, still using only three colors and black. We will then study a series of rules and pieces of advice about selecting and studying the subject matter, about the art of composing, and go on to the practical application of this knowledge in the step-by-step development of two landscapes in the open air, one painted with the usual watercolor technique and the other with the wet watercolor technique. Finally, as the ultimate, definitive practical exercise of this book, Fresquet will paint the watercolor *Barcelona Harbor* for you, with a detailed development that you can follow in painting the same picture as a final, practical exercise.

110

WATERCOLOR
—IN—
PRACTICE

Fresquet paints a still life

Still working with only the three primary colors (and black), Fresquet has selected and composed the subject. At the end of a table next to the wall, he has placed a canvas that serves as a tablecloth. On top of it are an apple, two bananas, a green ceramic jar, and a lemon.

First stage (fig. 114)
Fresquet begins by sketching the model with quick strokes. First he puts in the jar, then he draws the bananas and the apple, then the lemon. With a few lines he marks out the shape of the cloth and gets ready to paint (fig. 113). As before, Fresquet first wets the paper with clean water.
Not waiting for it to dry, he tones the picture at great speed.

These are the colors.

This is the order Fresquet follows:

Background, beginning on the left: Dirty ochre composed mainly of yellow, crimson, and black with a lot of water.

Background, right side: Without washing the brush, he takes a little blue and black . . . a little water to reduce, tries it out on a scrap of paper, then paints.

Jar: A layer of light green (yellow and blue), with the highlights reserved, then another layer with more color, with a more intense green, painted on wet.

Cloth: Blue-black taken from earlier mixtures.

Apple: Without cleaning the brush, he takes yellow, mixes it on the palette box with the previous gray, and just paints, reserving the highlight, then takes yellow and "leaves" it on top of this first layer. The wetness will ensure that it is spread and blended.

111

112

Fig. 111. Fresquet in his studio: a room about 4 × 4 m (13 × 13 ft.), a typical professional painter's studio, with the worktable next to the window and dozens of drawings, pictures, and sketches next to tubes of colors, brushes, and jars of water; this ordered disorder bears witness to the continuous, feverish activity of a professional who works and paints at every hour of the day.

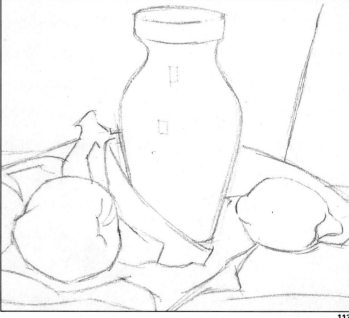
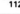

113

Lemon: He attacks the lemon, first cleaning the brush, then taking yellow and water. He gives a first coat, taking care to reserve the white.

Bananas: A fast, overall coat with the same yellow.

Apple (still moist from the previous coat): He takes crimson . . . a little blue . . . more crimson, water . . . and paints the darker parts.

Table, foreground: He mixes this greenish gray with leftover grays, a touch of yellow, and blue. He paints with plenty of water.

Lemon: He goes back to the lemon and models it with a yellow ochre. Since the area is not completely dry, the color spreads and blends, but Fresquet has to help gradate the lighter part in the center. He does this by squeezing the brush with a rag and lifting color.

Bananas (they are still moist): He takes color from the green-gray mixed for the table foreground and models the shape of the bananas with these greenish touches, without clearly defining the edges.

Fig. 112. The technique of painting wet-on-wet is applied by Fresquet in various areas in this still life. Here we see him painting the color and shape of the lemon.

Figs. 113 and 114. In these images you can see the line drawing with which Fresquet begins to paint this still life and the state of the watercolor when the first phase is complete.

114

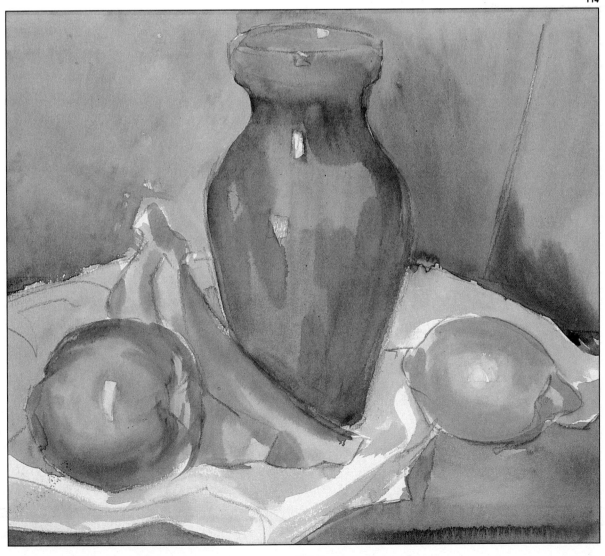

Fresquet paints a still life

Fig. 115. In this final phase, Fresquet works slowly, calculating and studying each brush-stroke, painting from less to more, trying to obtain a good finish.

Second stage (fig. 115)

We are not going to follow point by point. By looking at the figure, we can see, with no further explanation, that Fresquet has been working here with a range of colors similar to the previous one, only more intense.

As before, he began with the background, with a light sienna wash, and then intensified it wet-on-wet with this bluish, crimsonish shade. He has raised the other colors and increased their definition by glazing, almost al-

ways working wet-on-wet (an almost imperceptible wetness, but one that still produces the blurring of outlines and blending without manipulation), except in parts such as the cloth and the bananas, where we can observe lively, sharp, dry brushstrokes. He has begun the superimposition of dark greens, composed of blue, yellow, and black, on the jar. On the apple we can begin to glimpse the specific shape of its crimson areas.

115

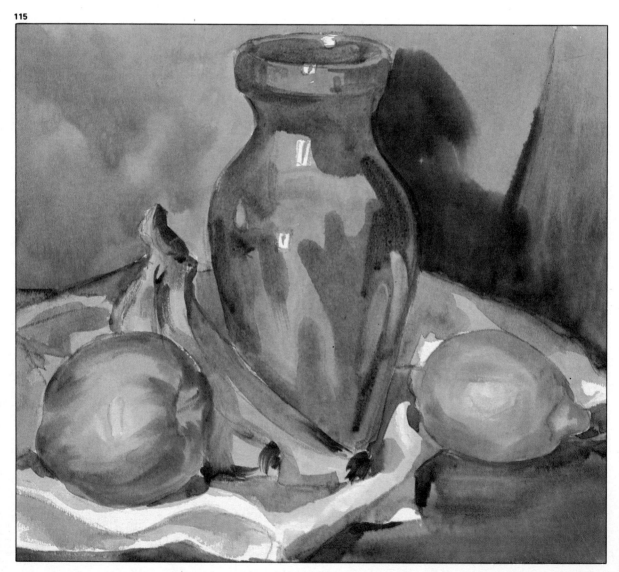

Third and final stage (fig. 117)
To reach this magnificent finale, Fresquet has spent two hours (one hour and fifty minutes, to be exact). Observe and study the parts that you can discern were painted on wet and the areas or forms painted dry, with the brush almost squeezed out and the color scrubbed (see the edges of the apple on the upper part and left contour). Study the coloring of the green jar carefully: It was done with superimposed brushstrokes, the highlights and reflections reserved and the brushstrokes adjusted to "what the model tells you," the only way to achieve an artistic representation of reality.

Do not lose sight of the fact that in all shadows there is always blue (assisted by black at some points). Remember that to gray a color you always need blue and that all slightly dirty colors contain blue.

Figs. 116 and 117. This is the extraordinary result achieved by Guillermo Fresquet, a watercolor painted wet-on-wet in the parts of the model that require it and in dry—in fact, the watercolor itself—in other areas such as the upper contour of the apple (fig. 116).

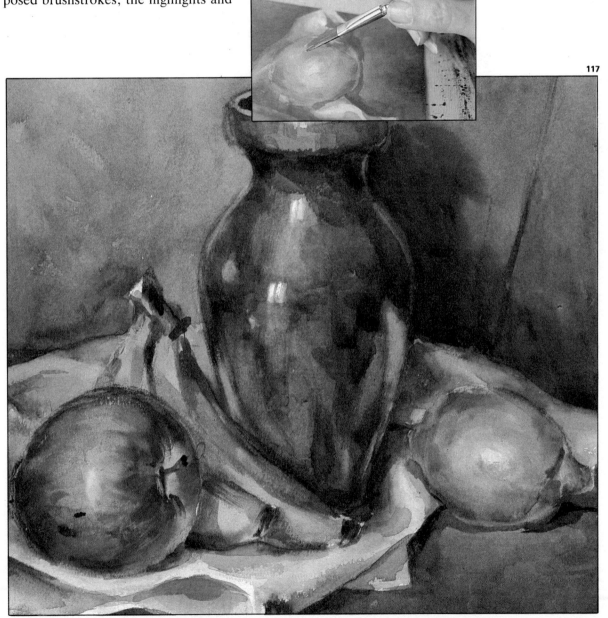

116

117

Selection and preliminary study of the subject

1. Study and accumulate the experience of other people by analyzing the works of masters.

Go to exhibitions or build up a small but select library of art books. Then analyze these works, study them, and even draw small diagrams of them so that you can gradually form and develop your capacity for composing and selecting.

2. Go to places where artists go.

It is well known that such-and-such a town is a haunt of artists, that in such-or-such a district there are always professionals or expert amateurs paint-ing. By painting where other artists paint, you can acquire a capacity for "discovering" new places and painting new subjects.

3. Study and try out a composition by drawing small sketches before painting the final picture.

When the moment comes to decide on the cropping, the viewpoint, the lighting, and the most appropriate contrast, you should draw one or two rough sketches, something that is done not only by amateurs, but also by most professionals, including Fresquet and me.

118

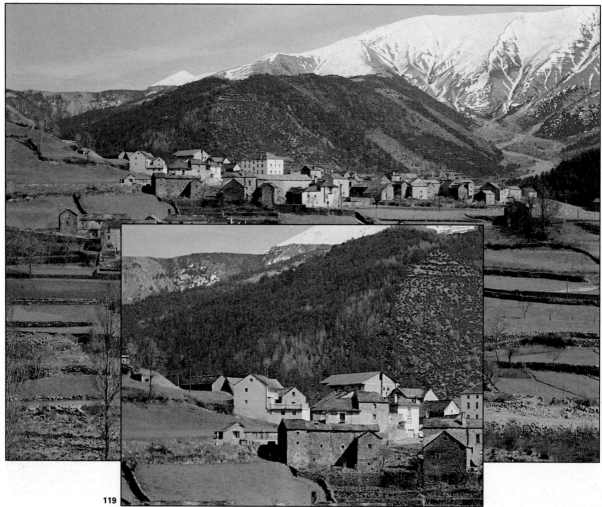

119

General rules for the art of composing a picture

We must remember some of the classic rules for obtaining a good composition for a landscape, also remembering, however, that the art of composition is not the product of rules and logic but something the artist carries inside (though it can be cultivated and developed).

First and foremost, you must exhaust all possibilities. That is to say, you must look at the subject from every possible angle and analyze the position of some forms in relation to others and try to obtain contrasts of shape and color. The direction, intensity, and quality of the light are important in this respect. Cropping is also important, and it can be analyzed through a simple black cardboard frame with an aperture of about 10 × 15 cm, or 4 × 6 in. (fig. 120).

Figs. 118 to 120. The model cannot move, but you can. Study all its possibilities. Look at it from above, from below, from one side or another, and from nearer or farther away, making the subject wider or narrower. For this preliminary study, many artists use a cardboard frame formed by two angles like the one you can see on this page.

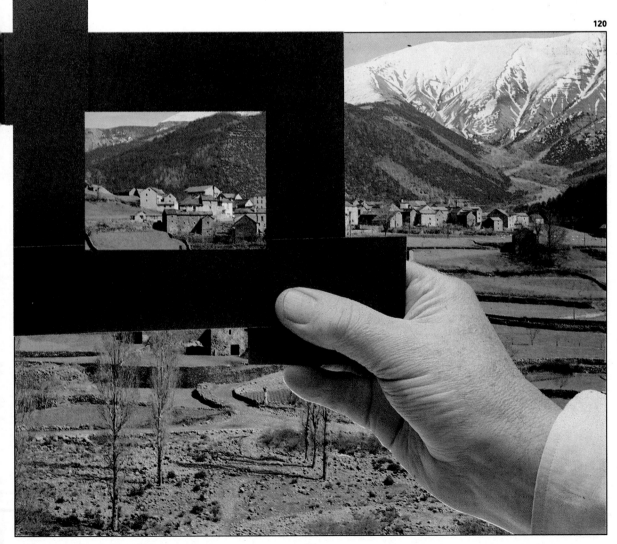

120

Five pieces of advice about the art of composition

Fig. 121. The formula for cropping an image with a foreground that stands out in form and tone gives sure results in terms of artistic composition.

Fig. 122. Observe that this foreground serves as a scenic plane to give the feeling of depth and provides the necessary compositional units at the same time.

● We must remember—and apply from the beginning—the classic method for composing a landscape, which is based on the selection of a subject with an *outstanding foreground superimposed on two or more grounds behind,* which give the illusion of depth.
● The third dimension can also be brought out through the contrast of the foreground against less color in more distant grounds.
● The tonal and chromatic mass of the sky can in many cases be a decisive element in ordering and harmonizing the composition of the subject. This can easily be tested in watercolor painting,

in which the skies can give decorative effects of great technical brilliance.
● Finally, do not forget the possibility of using perspective in the composition of a landscape as an element to help create unity within variety.
Is there anything else?
Yes, the lighting of the subject.
● Unless you decide to paint a landscape with a cloudy sky, I would recommend that you paint before or after midday to avoid the noon hour when sunlight strikes objects vertically, a direction of light that practically eliminates shadows or casts rather disagreeable ones.

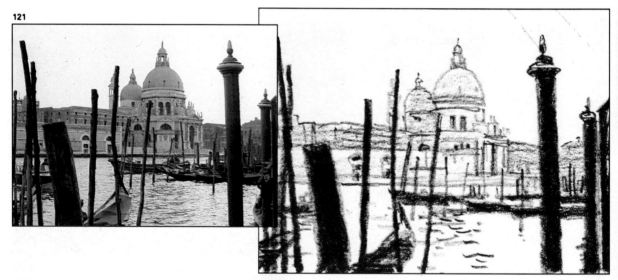

121

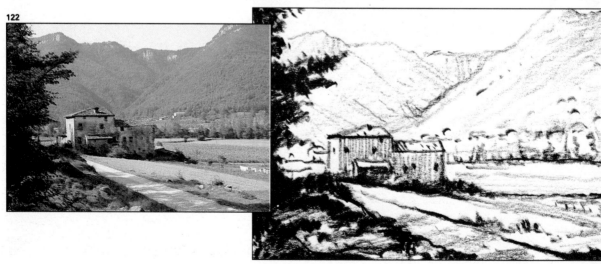

122

123

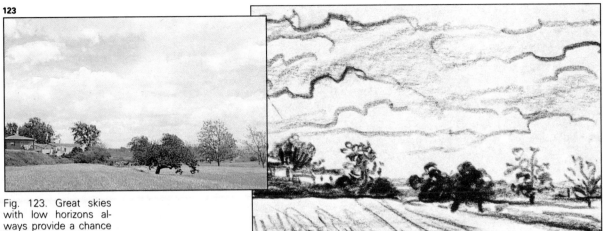

Fig. 123. Great skies with low horizons always provide a chance for achieving spectacular effects.

124

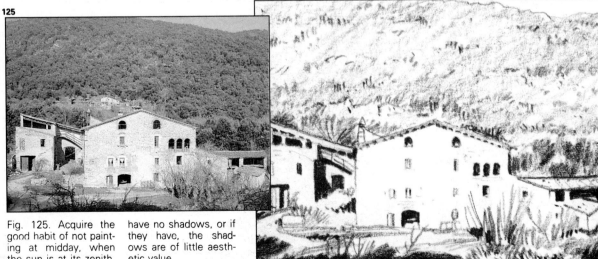

Fig. 124. Remember that you can use perspective as a means of ordering the composition and accentuating the feeling of depth.

125

Fig. 125. Acquire the good habit of not painting at midday, when the sun is at its zenith. At that time objects have no shadows, or if they have, the shadows are of little aesthetic value.

Atmosphere and subjects

It is well known that English water-colorists traveled to Italy confident that they would find a host of subjects to paint there. With the same idea, Turner went to Venice, and Delacroix to North Africa.

Fresquet has been in Morocco recent-ly. "It's another world, quite differ-ent." He speaks with genuine passion. "A world of form and color where you can find one subject after another, an infinite number of themes for painting and drawing. In the outskirts of the city, the landscape provides marvelous contrasts of light and shadow, brought out by the intense, luminous cobalt blue of the sky, the blue and violet sha-dows, and most of all the technicolor parade of men and women with their white jelabas, their gray, dirty earth-colored robes. . . . It's fantastic!"

You, too, can live the experience of Turner, Delacroix, and Fresquet by traveling to a particular place . . . or not; think that the place might be in your city or just a few miles from where you live, in an old town or a spot by a river.

126

127

Figs. 126 to 130. Fres-quet traveled to Mor-occo recently, reliving, perhaps, the sojourns of many artists who have visited its villages, cities, and other sites to paint. "I intend to go back," Fresquet says. "There are dozens of subjects to paint there." Indeed, Fresquet made a huge number of sketches and pictures, drawing with a pen or a reed, painting with ball-point pens, and prod-ucing magnificent watercolors.

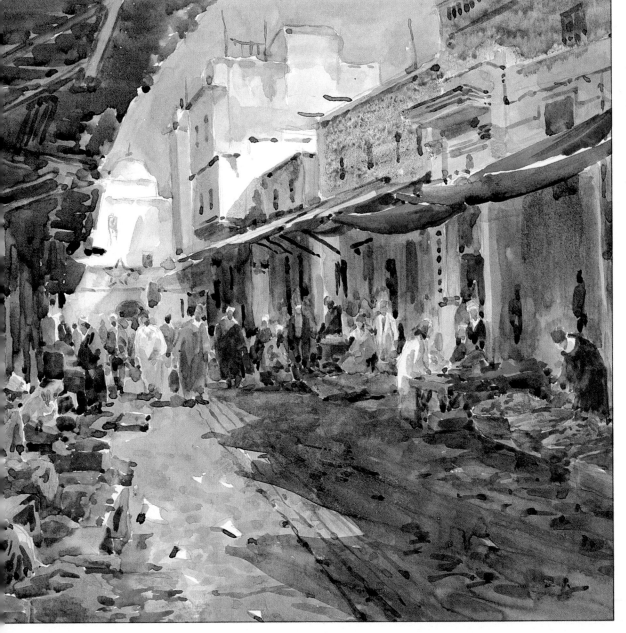

Making a rough sketch of the subject

Fig. 131. Guillermo Fresquet looking at the scene and doing a rough sketch with lead pencil. Although Fresquet's experience enables him to evaluate the qualities of light or the forms of the scene at a glance, like many other painters he usually draws a sketch to confirm that he has found a good composition.

It is quite possible for an experienced professional like Guillermo Fresquet to know at a glance whether the subject or model in front of him is suitable for transferring to canvas (or to paper in this case), if the lighting is the best —"at that time, in that place"—to bring out the values of the model, whether the form, the arrangement of the elements, the color, and the contrast of the different grounds can provide a good picture. Nevertheless, it is quite common—as Fresquet says himself—for the professional to want to confirm this first visual impression, to put it down and perfect it by means of a simple pencil sketch.

"As you can see," he stresses, "what interests me most in making this rough sketch is deciding on the cropping and studying the effects of light and shadow in relation to the composition."

In figures 132 and 133 you can see some of the small-scale sketches done by Fresquet with a lead pencil in order to observe and consider the effect of each composition more quickly. Notice the structure of these sketches, done with shading rather than lines, and you will appreciate the full value of

the possibilities offered by the subject. Imagine that we have gone with Guillermo Fresquet to a town in the province of Tarragona and we are standing beside the narrow road that leads into the town. As you can see in the sketches and in the photograph of Fresquet drawing the subject, there are houses on either side in the second ground, separated from us by the green and earth color of some gardens and trees. It is 10:30 in the morning on a spring day, and the sun lighting the scene is producing strong contrasts in the play of light and shadows. The volume of the bodies is extraordinary.

But wait: it seems Fresquet has something to say:

"Yes. I think this is a suitable subject for a watercolor painted with a technique that some people call the dry technique, as opposed to the *wet watercolor technique*, but which, in fact, is the normal technique that has always been used in watercolor painting."

While he is explaining these two extremes, Fresquet is laying out his watercolor equipment in the open air, fixing the paper to the board, and getting ready to start painting the picture.

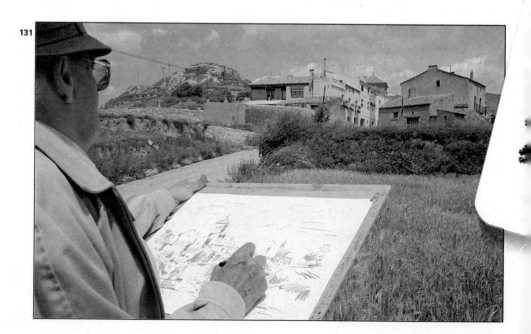

131

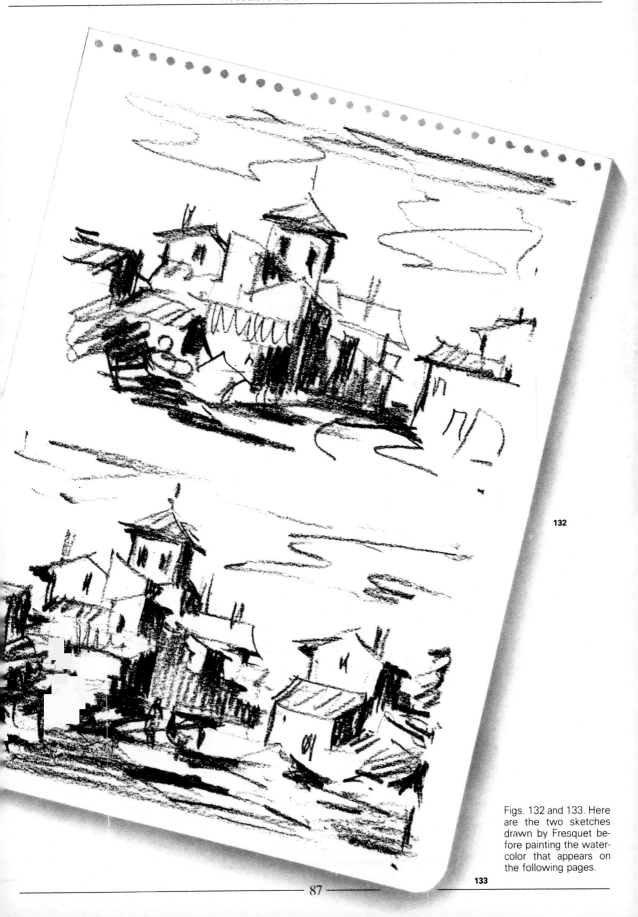

132

133

Figs. 132 and 133. Here are the two sketches drawn by Fresquet before painting the watercolor that appears on the following pages.

Fresquet paints a landscape

Fresquet starts by wetting the drawing paper. Remember that when painting with watercolor you always have to begin by wetting the paper in order to eliminate residual grease and to prevent the color from cracking later or the paper from releasing the more liquid washes.

Now Fresquet waits for the paper to dry completely and then does a rapid drawing of the outlines in a lead pencil: a very simple construction, *absolutely linear*, that is, without a single shadow or shading or black.

While he is sketching shapes and drawing outlines, a peasant leading a donkey passes by on the road. Fresquet observes for a moment or two and, drawing practically from memory, places the man and the animal on a bend in the road.

"We should say that you must always incorporate one or two human figures into the picture whenever natural and possible, because apart from providing a note of color—later I'll add a touch of red to the man with the donkey and blue to the one in the background—they give a feeling of life and reality."

"I always begin by painting the sky"
"For any particular reason?" you may ask. Well, yes, for various reasons, Fresquet answers. First and foremost because when you are painting with watercolor, the skies of a landscape have to be done straight off, painted at a stroke, not retouched, left just as they come out on the first attempt.

In a landscape there may be hills, houses, trees, and the like, which present different planes with different colors, different effects of light and shadow and therefore different values, and they usually occupy particular, limited spaces. It is natural and essential to paint these bodies part by part, drawing forms and superimposing or juxtaposing colors. But the sky does not contain such a variety of forms and colors. The sky is a whole. Even though

there is the white and gray of the clouds, there is a uniformity of color, a dominant blue, which cannot be represented by means of small touches or superimposed color.

Painting a broad sky is not an easy task. Or rather, it calls for great skill: you have to know how to carry the water and the color in order to avoid cuts and—just as difficult or even more so —you have to have sufficient experience and courage to get the color right. This is a truly complicated business when you think that the rest of the picture is still white.

"Well," Fresquet interjects, "you shouldn't make the business seem so grim. Painting a sky with watercolor is the work of a moment. Just because of this business of painting it cleanly, 'the water making itself seen,' as we say, leaving it fresh and spontaneous, it has to be painted in a matter of minutes. If you are unlucky enough not to get it right, you can always start over.

"You'll see," says Fresquet, "look, see how quickly it's done."

First stage (fig. 134)
In the cavities of his palette, Fresquet mixes a neutral, slightly grayish blue, made up of ultramarine, cobalt blue, and a pinch of sienna.

He also prepares a gray composed of ultramarine and sienna, And another gray that also contains a touch of crimson. And he paints. The paper is completely dry.

Fresquet loads the brush with water, picks up blue, and paints on the upper left. The blue is rather light, with a small quantity of liquid. He goes right off in search of the gray. Fresquet paints below the previous blue. When the two colors come together, they blend and mix.

He squeezes the brush with the rag and applies it to the lower part of the gray, lifting color, lightening, while with a firm brushstroke he outlines or draws the silhouette of the roofs.

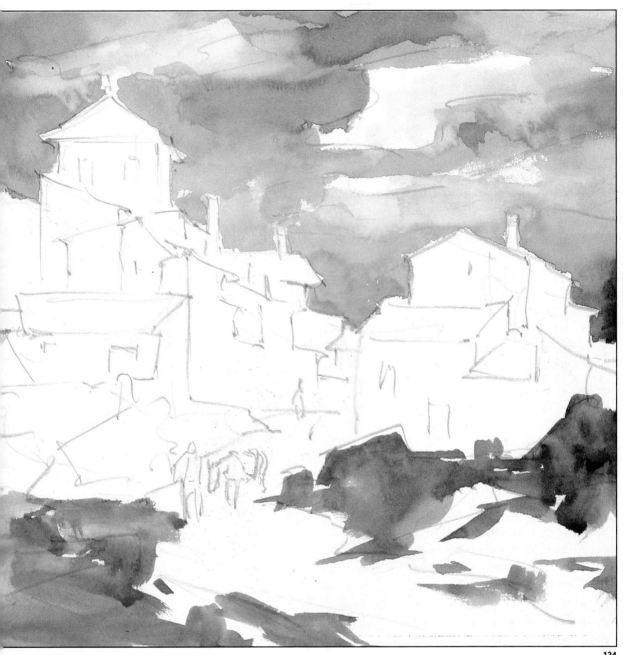

134

Above, the initial light blue still preserves a tiny bit of moisture; it has not yet dried completely. Fresquet loads the brush with water and darker blue and paints on top of the light blue. The darker blue spreads like a stain . . . flows out . . . flows wherever it still finds moisture, and then stops. Summing up what we have seen so far, we might say that in theory Fresquet ap-plies the color to the dry paper, but then, while the first color is still wet, he quickly paints with another color, juxtaposing it to the first and allowing the two, as they meet, to mix and melt together through the effect of the moisture.

Fig. 134. Trying to fill in, to eliminate the white of the paper, to achieve a better harmony of colors in general, Fresquet, like many artists, begins by painting the sky.

Fresquet paints a landscape

Second stage (fig. 135)

Look carefully at figure 135. You can see a feature that is common to all subjects painted from life: the fact that the artist, having painted the sky, "attacks" the darker parts of the subject and paints the intense colors, leaving aside the medium and light shades.

Quite a dramatic effect, isn't it? And how pleasant to be able to paint like this, drawing, modeling, defining the volume of the forms, with a chance to go back, to do it again if necessary with a new coat that intensifies or tones the color.

Naturally, a technique like this one has to result—as we can see for ourselves—in a final image that has contrast, power, and great effect. Which leads us to conclude that:

> **Watercolor is also suitable for painting subjects or models with a lot of contrast in themselves. A classic model is the landscape flooded with sunlight.**

Ah, but note the care with which Fresquet has painted the forms that will call for medium or light colors. The little figure in the background, for example, or the chimneys of the houses.

In this second stage, study the way Fresquet does the painting of the roofs —each with the color provided by the model. He does not work in a series with the same color for all of them, as some inexpert amateurs might do, unfortunately; rather, he simulates the graphic quality of the roofs with clean lines "opened" with the tip of a brush handle, as we explained earlier.

Third and final stage (page 92)

Having reached this point, Fresquet first paints the lighter areas, the color washes that cover broad expanses receiving the most light: the light color of the road, the kind of yellowish cream that illuminates most of the houses. Fresquet paints these light areas with broad brushstrokes, not worrying too much about whether he is "overstepping the mark." When he reaches parts where it may be necessary to paint later with a darker color (such as the walls and ground at left where later he will paint the trees), he paints all of the area with the light color.

Observe in these light colors—and in the coloring in general—Fresquet's concern to achieve variations that enrich the painting. Analyze each of the planes of color that correspond to the illuminated walls and you will see that in some of them the tendency is yellowish, in others pinkish. You will see that even within each plane there are tiny variations, soft but evident touches of color that enliven and raise the artistic quality of the painting. Look, for example, at the series of fine shades in the coloring of the road.

Fresquet now paints intermediate values, colors such as the front wall of the house on the right. In this case and in no other he applies these intermediate colors while the original light color is still wet. This is what he is doing now with the trees on the left, almost in the foreground, which are painted entirely with the wet watercolor technique, first in light green and then in the darker green corresponding to the parts in shadow.

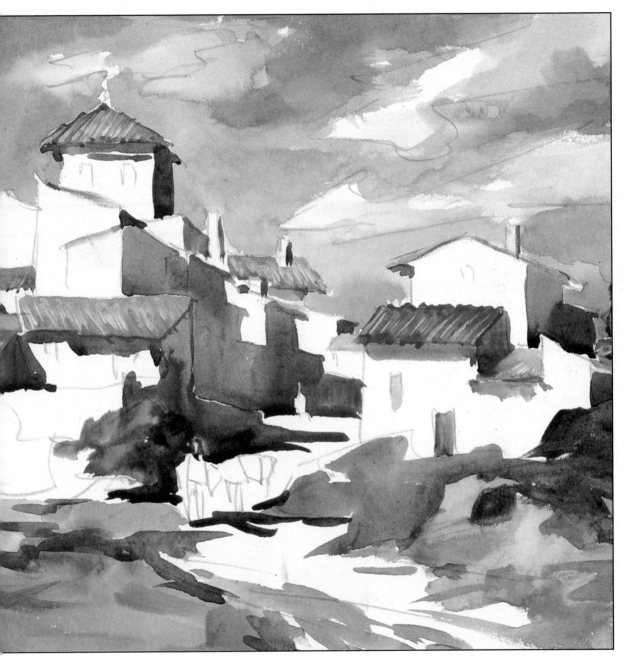

135

Fig. 135. Corot repeated this piece of advice to his pupils over and over again: "First the shadows: paint the play of light and shadow first of all." Fresquet is following this general rule here, bearing in mind the lighting and the contrast provided by the subject.

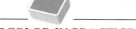

Fresquet paints a landscape

Now he paints the figures, doors, and windows and the horizontal shadows in the foreground, using thick, spontaneous brushstrokes.

Last comes the finishing, which consists first of balancing some values, strengthening colors at certain points, and lifting or reducing at others.

The only thing left is to see how Fresquet takes out small whites with the tip of the brush handle and the edge of his fingernail, creating the lines or scratches on the grass in the foreground —done here with the brush—or the broadish yellow lines on the right side of the road—done with his fingernail. You can also see the two small light vertical lines representing the windows of the houses on the shady side of the street.

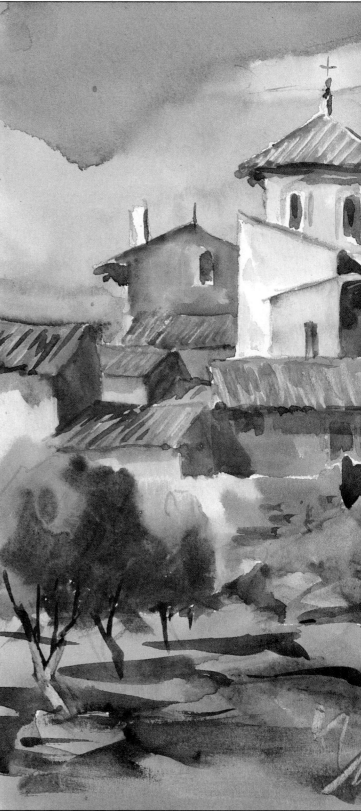

Fig. 136. The final result obtained by Guillermo Fresquet in the watercolor painted specially for this book. The original picture is slightly larger than this reproduction (exactly 25 × 32 cm, or 10 × 12 1/2 in.).

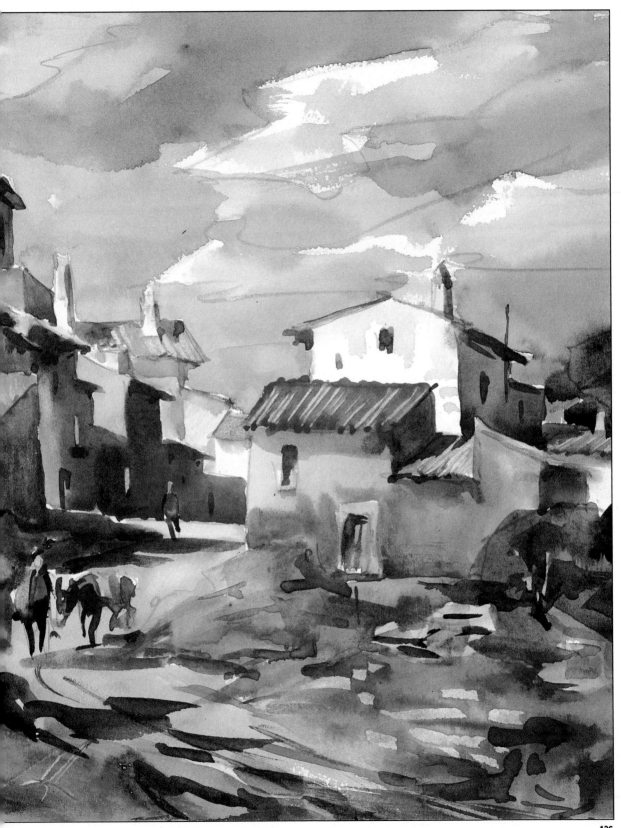

Fresquet paints a "wet" watercolor

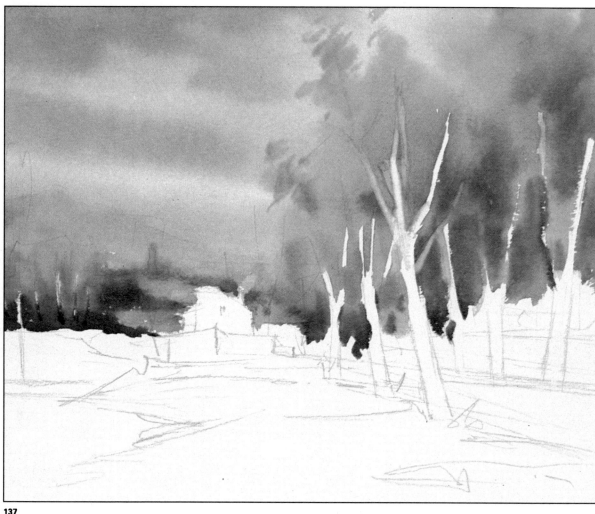

137

Fresquet called me at midday: "Parramón! It's stopped raining, there are clouds in the sky, and it looks as if the sun's about to come out. Shall we give it a try?"

And here we are. Fresquet assures me that the time when he discovered it on an afternoon like this, driving along this road, "that time"—he says—"it was even better. Over there, in the background, there was a *golden* light!" So we begin. As before, he wets the paper first to remove the grease. Then he sketches out the subject with four or five lines, just enough to put everything in its place. (You should see how confidently Fresquet draws!) In this case, there is no rough sketch. Fresquet knows the cropping, the contrast,

the coloring, the composition, and—of course—the lighting by heart.

The first step, indispensable for the wet watercolor technique:

First stage: wet the paper in order to start painting on a moist surface (fig. 137)

"This wetness," Fresquet insists, "mustn't be overdone. When you look at the surface of the paper at an angle coinciding with the direction of the light, you shouldn't be able to see the shine of the water itself."

Fresquet is now applying the first wash with clean water. As he does so, he takes particular care to reserve the whites of the tree trunks, as well as the whole lower area.

Fig. 137. Here, too, Fresquet also starts with the sky. In this case, following the wet watercolor technique, he has first moistened the sky area and reserved the lower part of the picture to dilute, lift, intensify, and paint the color with the *wet-on-wet* technique.

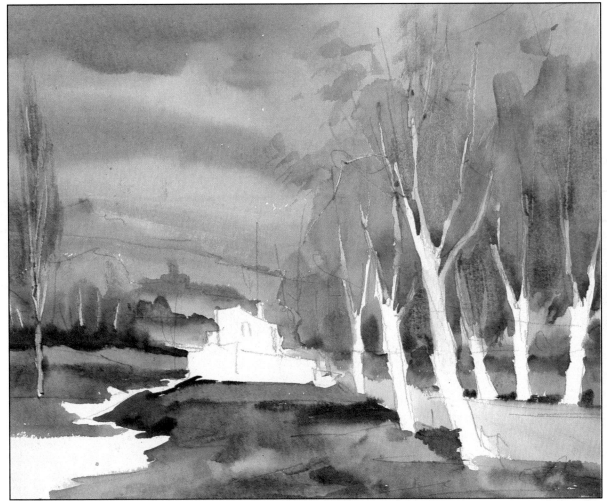

138

But let us continue. Fresquet is already starting to paint. He begins the picture with the upper left part of the sky, applying a light gray with a warm tendency to the wet surface. He spreads the gray toward the right, diluting it with more water as he comes closer to the treetops. He even invades this area, gradating with clean water in the center. Then he hurries to spread the light gray downward. Almost on the real horizon, he adds a tiny touch of crimson to the gray. He goes to the upper left part and applies a slightly pinkish but still light gray.

Then he mixes a darker gray and paints the great dark clouds with broad brushstrokes. Assisted by the moisture, the color spreads slowly, smooth and uniform. Fresquet helps by lifting liquid where it accumulates and adding it where necessary with featherlight touches . . . "It's better to leave it," he says. "A bit too much and the sky is ruined!"

Now he paints the castle mound with ultramarine, sienna, and crimson . . . He lifts color in the upper part and adds a more crimson brown.

With extraordinary speed, Fresquet composes the ochre of the trees, mixing the color with sienna and a touch of green, neutralizing with red or crimson when he wants a pink ochre or with ultramarine when he paints the greens with a khaki tendency. He applies the same range to the trees on the left, next to the horizon.

Fig. 138. Observe the care with which Fresquet maintains the whites, which he will eventually paint when the work done so far has dried. Also observe the series of shadings and gradations on wet, combining the technique with dry painting.

Fresquet paints a "wet" watercolor

Second stage
(fig. 138, previous page)
Fresquet continues with the technique described on the previous page. He is now painting the ground, earth, meadows, and the light gray line of the road. As before, he begins by wetting the paper with clean water, reserving the whole shape of the building and the area of the brook, as well as the whites of the tree trunks.

Observe how, in this ground made up of earth and meadows, the colors blend at this stage, leaving every opportunity to correct, take away, or add while the paper is still wet.

Third and final stage (fig. 139)
On the more distant tree trunks, Fresquet paints a rather dirty cream colored glaze to make them appear more distant. Then he models the cylindrical shape, applying burnt grays, but on the two closest trunks he leaves the illuminated parts in the white of the paper.

On the building he first "dry" paints the general light tones and then models with the dark ones, applied while the previous layers are still wet.

Finally, painting dry, Fresquet draws the tiniest shapes such as the slender tree branches, the shadows of the trees on the road, the grass, and the lines or strips separating one meadow from another.

Finally there remains the task of balancing some colors, adding or subtracting, and opening up some particular white with his fingernail.

The job is finished. We drive back to Barcelona. We have a date tomorrow morning at the harbor. Fresquet will paint a large-scale watercolor for us.

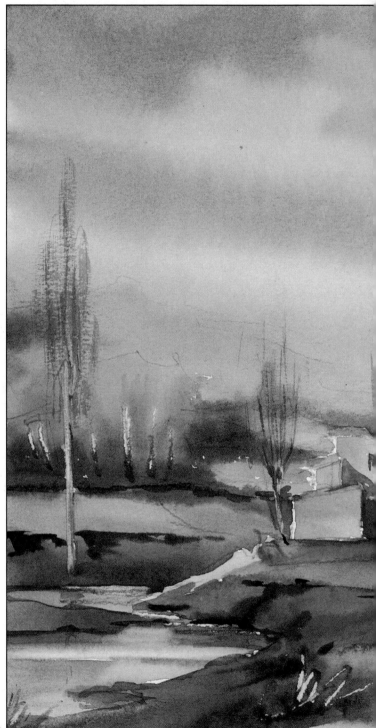

139

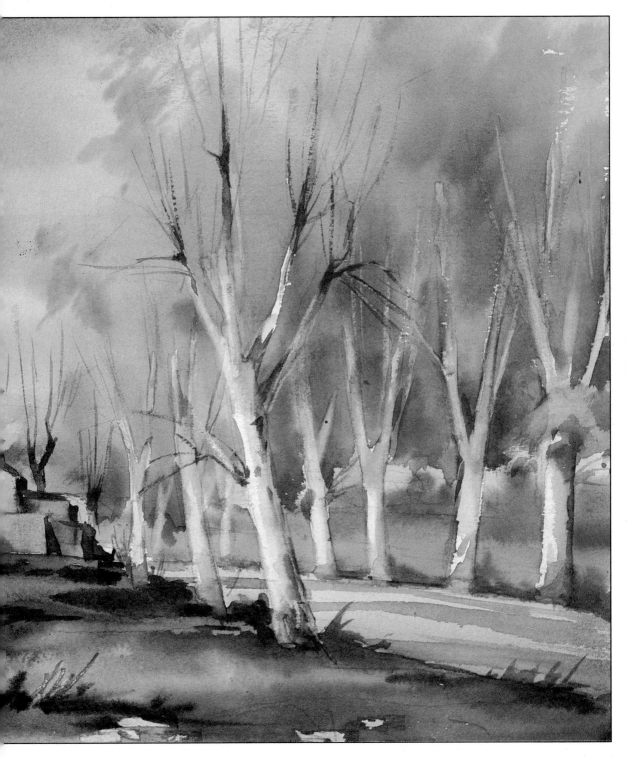

Fig. 139. This is the result Fresquet obtained in the final watercolor painted especially to teach this technique. (The original painted by Fresquet measures exactly 25 × 32 cm, or 10 × 12 1/2 in.).

Now you paint with Fresquet

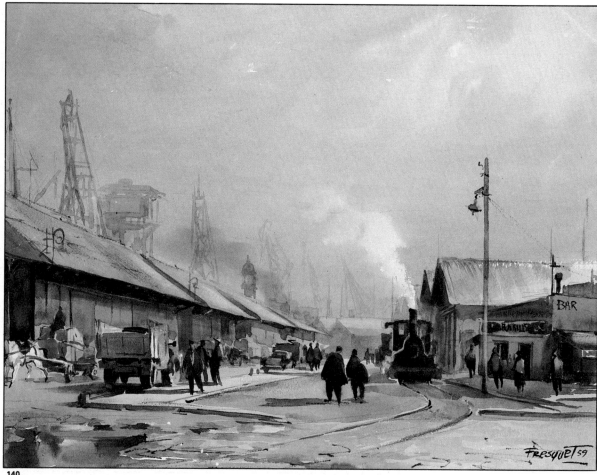

140

Finally, here is the last lesson in the book, the final exercise. You are going to paint in full color Guillermo Fresquet's watercolor *Barcelona Harbor*, reproduced on this page in small scale and again on pages 106 and 107 in a larger scale. In this reproduction and in the images on the following pages, you can see the step-by-step development of this watercolor. Do you dare to paint it yourself? Can't you see it already painted by you, framed and hung on a wall in your house?

The original size of this watercolor is 33.5 × 48 cm (13 × 19 in.). So first take a sheet of quality paper that is somewhat larger, draw a centered rectangle 33.5 × 48 cm, and trim off the surplus paper, leaving margins of 3 or 4 cm (1 1/2 in.) around the outside.

These 3 or 4 cm are used to hold the paper down with drawing pins or to mount it with strips of gummed tape, as explained on page 31.

Construction with the grid system (fig. 141)

In figure 141 you can see a small-scale reproduction of the original pencil drawing done by Fresquet.

Make a grid of Fresquet's drawing and transfer the enlarged grid and drawing to your drawing paper.

When the drawing is finished, carefully rub out the lines of the grid and wet the paper with a sponge or broad-ended brush.

Fig. 140. This is a reproduction, reduced to a small scale, of the watercolor *Barcelona Harbor* painted by Fresquet. To begin to copy this watercolor in the original size, 33.5 × 48 cm, you can make a grid of the reproduction and draw the enlarged grid on your drawing paper to ensure the correct construction of the drawing.

141

First stage: painting the sky and general toning (fig. 144)

"I always begin by painting the sky," Guillermo Fresquet told us earlier. This is what you are going to do now, bearing in mind that the sky plays an important part here, that it must be painted on the first attempt *using the technique of wet watercolor*. Yes, this is a watercolor in the classic style, but many of its parts have to be painted with the wet watercolor technique. To begin, then, assuming that the first wetting of the paper has already dried, wet the whole sky area with just a little clean water, including the warehouse roofs (the zone marked out by the blue line in figure 142 on page 100), and now you can paint.

But wait a moment! Let me point out one important aspect of the color:

The dominant color is blue-sienna.

If you mix ultramarine and burnt sienna with more or less water, you should obtain a similar color to the one in many of the zones painted in this picture: a color that goes from a neutral gray or a cool or warm gray to a dirty blue or a grayish sienna, according to whether the amounts of each are greater or smaller. And now start to paint.

These are the colors; in the order to follow:
Sky, right center part (fig. 142, over): ochre, cobalt blue, and red.
Working wet-on-wet, apply to the center, in the zone indicated by the letter A, a predominantly ochre-colored wash, mixed with a small amount of cobalt blue and the lightest touch of red. When you apply this mixture, the

Fig. 141. Here is the reproduction of the drawing done by Fresquet, which you can take as a model of simplicity and synthesis of forms. You can see for yourself that it is not necessary to draw lights and shadows; just do a line drawing.

Now you paint with Fresquet

142

water will dilute and spread the color to about the edge of zone A (blue line).

Sky, left part and center (fig. 142 B): cobalt blue and sienna as the basic colors.

Mix a sufficient amount of this combination, bearing in mind that it is the basic or dominant color on the whole sky. Spread this blue-sienna from B, incorporating it with the ochre until you reach the original zone A.

Important: the surface must still be slightly damp.

As you proceed with painting the sky, always within the blue-sienna dominant, try to incorporate the lightest shades of pink, pinkish crimson, and very light green, so that the expanse of sky is not uniform.

The smoke from the engine (fig. 142 C

and D). When you reach the smoke of the engine, reserve a white like the one indicated in C and dilute the sienna in D until you obtain the gradation of the smoke.

Black cloud of smoke on the horizon (fig. 142 E). Working wet-on-wet with the brush loaded with a mixture of ultramarine and sienna and just a little water, paint this cloud of smoke, allowing the moisture of the sky blue background to dilute this darker tone. In figure 143 on the opposite page, you can see that there are two contours that mark out the sky at the bottom. You have to paint with the blue-sienna as far as edge B and then gradate and dilute the color so that when you reach edge A, that color no longer exists and there is no abrupt cut. Finish this part of the sky (fig. 143 C), still painting with cobalt blue and sienna.

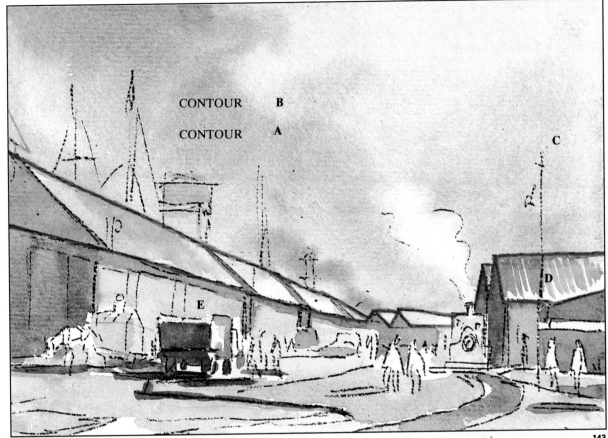

CONTOUR **B**

CONTOUR **A**

C

D

E

143

How to repeat the painting of the sky without changing the paper.

Let us suppose that the sky did not come out the first time, that there are cuts, puddles, or irregularities. There is one possible remedy, which consists of submerging the part of the watercolor paper that corresponds to the badly painted sky in clean water. Take it out and wipe it and put it back in again a few more times until the water dissolves the washes of the sky and it is ready to be painted again.

"It has to be said, however," Fresquet tells us, "that this remedy is not always effective. It fails when the sky has been painted with a lot of color."

Roofs of the sheds or warehouses (fig. 143 D): ochre, sienna, ultramarine.

Begin by wetting the zone of the roofs with clean water. Then paint with ochre or sienna and a touch of ultra-

marine and an even tinier amount of black, just to make the previous ochre sienna color grayer.

The warehouse walls (fig. 143 E): ultramarine, sienna, and a little crimson.

You have to obtain a grayish purple with a sienna tendency by darkening the shadow thrown by the roofs with ultramarine.

The ground in general: ultramarine blue, ochre, sienna, green, crimson.

Start with a very pale overall coat, composed of ultramarine, ochre, and burnt sienna, which will give a rather dirty cream color. Add a little green, sienna, and ultramarine on the left side. Continue with this color toward the right, incorporating a bit of ochre and a touch of red just to draw it toward pink. Finish with the most distant zone, which is painted with a little

Now you paint with Fresquet

more sienna and a little green, grayed with the ultramarine.
Be careful! When you paint the ground, you must reserve the whites that appear in the final painting.

Porch on the left side: sienna, green, and ultramarine.
Be careful! Reserve the shape of the horse.

Truck, packages, vehicles in the background.
On the truck there is a predominance of green, grayed with sienna. The packages on the horse-drawn cart are painted ochre with a tiny bit of blue, just enough to break the yellow stridency of the ochre.

Second stage (fig. 145)
I would almost imagine that with the mixtures you have made so far, you are capable of carrying on alone. Yes, because with those mixtures you will have understood which basic colors play in the overall effect of this watercolor; cobalt blue or ultramarine, according to whether you want more or less luminosity, must almost always be mixed with burnt sienna, which basically helps to obtain the gray with a bluish tendency in the sky and with a warm dominant on the bodies and objects in the remainder. On these bodies, ochre and green also play at certain points, the first to "yellow," the second to enrich. Finally, for the same purpose but in tiny quantities, red and crimson are used, and to obtain some grays you may need black.

Figures in the foreground: sienna, blue, and green.

Side and engine of the truck: ultramarine and crimson.
Bear in mind that when you paint the blue side and the crimson engine, you must incorporate the tiniest amount of sienna in the blue to avoid stridencies and a tiny bit of gray or light blue in the crimson for the same purpose.

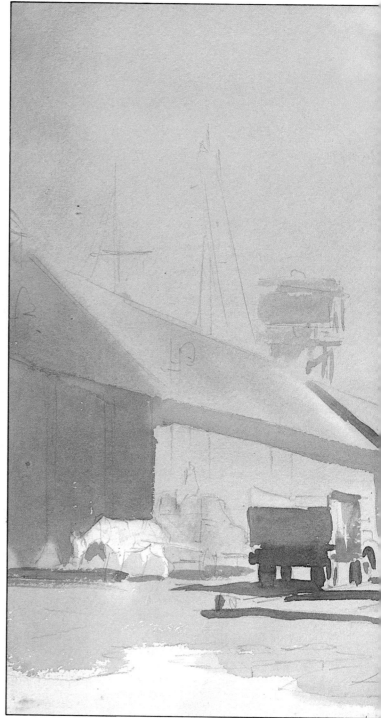

144

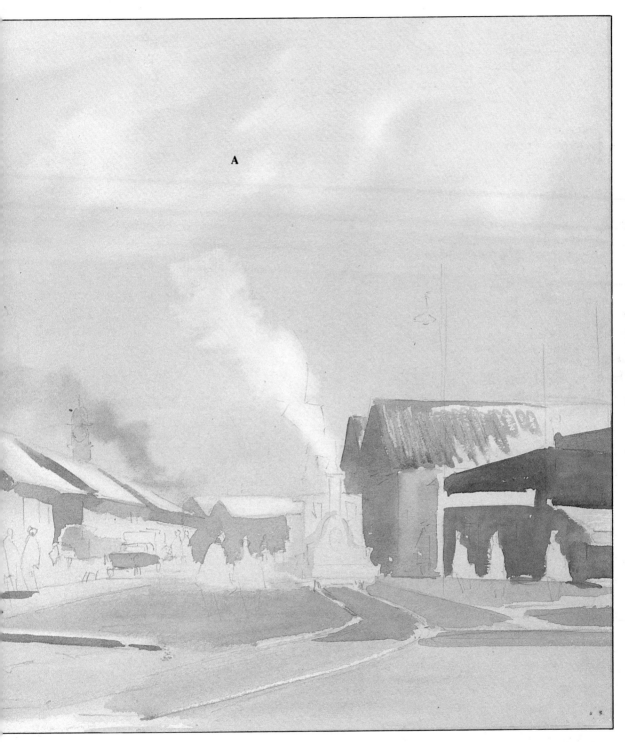

Fig. 144. Here is the development corresponding to the first stage of the painting of the watercolor *Barcelona Harbor*. Follow the explanations that tell how to obtain this first stage in the text, studying the colors to be used and the procedure to be followed.

Now you paint with Fresquet

Third and final stage (pages 106 and 107).

We are certainly not going to talk anymore about colors, but we are going to talk about some technical aspects related to the last part of the exercise.

Puddle in the foreground.
First, paint a coat of light color reflecting the color of the sky. Then, painting wet-on-wet, add the dark colors reflecting forms and shadows.

The ground in general.
As you can see in the development of the picture (figs. 144 and 145), the ground has been painted with two or at most three superimposed layers. Observe that the dark lines of the shadows were painted dry.

Lamppost on the right.
This lamppost may be reserved or painted with the dark gray, and the lower part lightened afterward with a squeezed brush lifting tone and color.

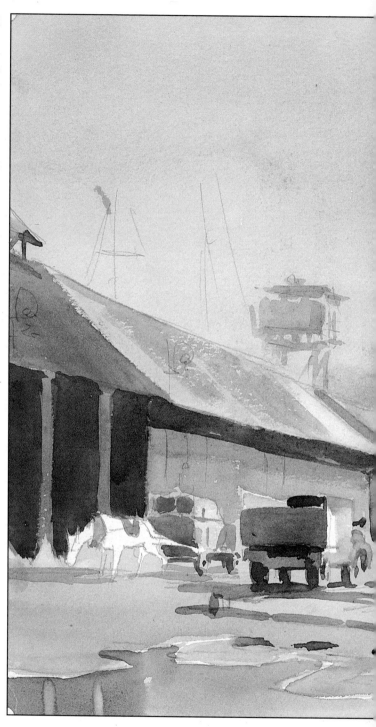

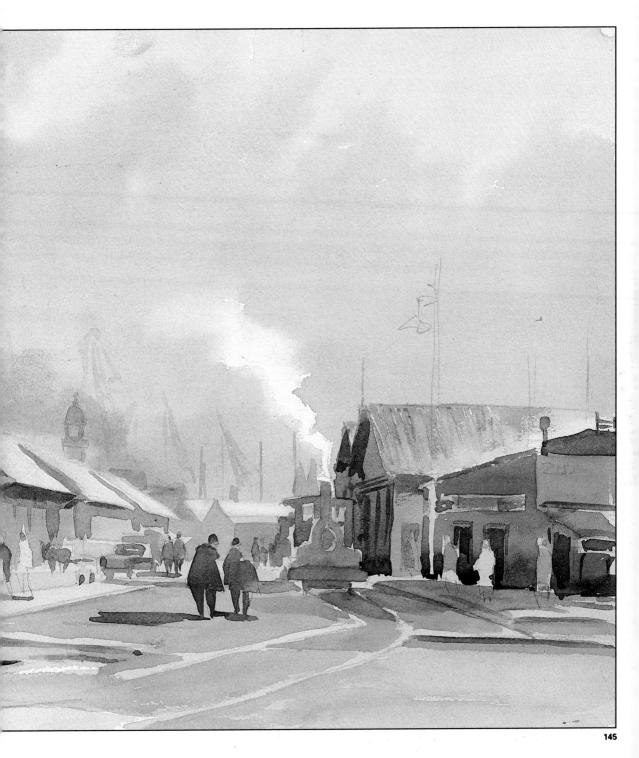

145

Fig. 145. On these pages you can see the coloring and toning that your watercolor must have when you reach this second stage. Observe the differences between this and the first stage and also compare it with the large reproduction of the final work (pages 106 and 107).

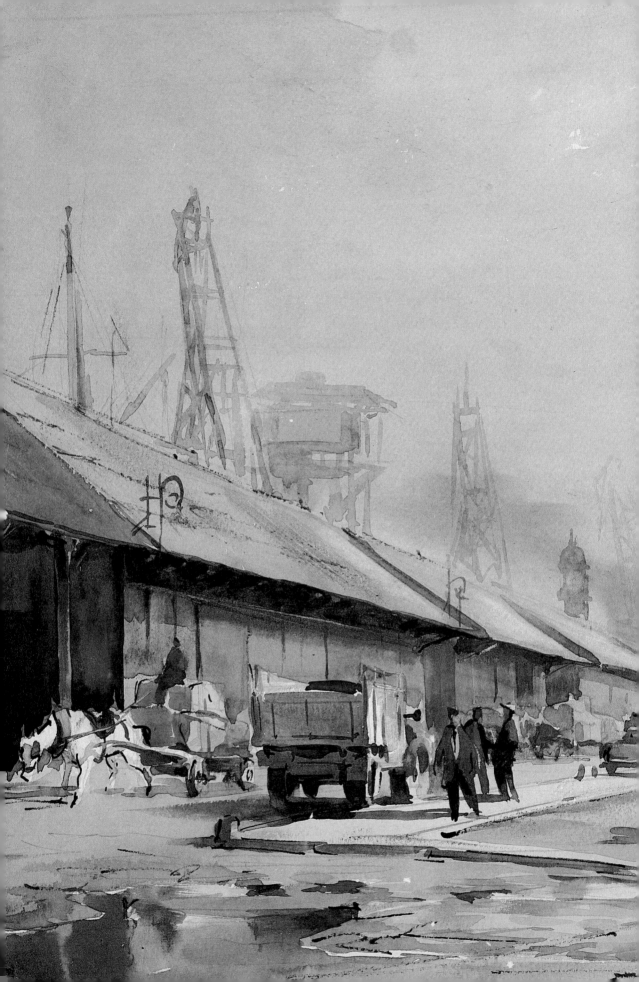

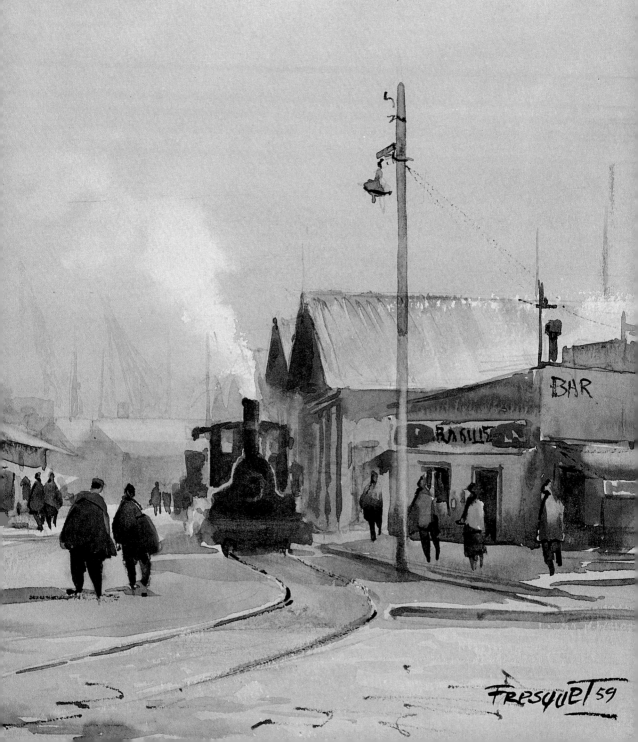

Finishing touches with India ink and a reed pen

This, as you can see, is a simple piece of reed cut on a slant at one end, in the shape of a pen and coming to a point. If you observe Fresquet's watercolor, you will be able to see some thick lines at certain points, the finishing touches; for example, on the railway line, on the edges of the roofs, and on the horse's legs.

Fresquet paints these lines with India ink and the reed, diluting the ink with water so that the line is not too intense. You need a small inkwell with the India ink wash already prepared for these effects. The reed is the ideal tool for obtaining a full, pure line or a diffuse grayish line produced by drawing with it almost dry, like the one used to draw electric wires on the lamppost on the right.

Fig. 148. In the final stage, Fresquet draws some lines with a reed and India ink diluted with water, bringing out forms and edges such as the railway lines, the edges of the roofs, and the horse's legs.

147

148

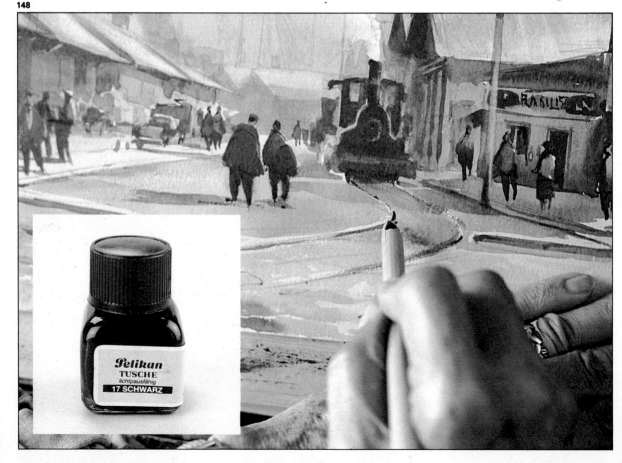

Signing... and fixing

Signing, of course, but did we say *fixing*? Well, yes. There is a kind of fixative on the market for watercolors whose purpose is not so much fixing as enlivening the colors. Bear in mind that when watercolor dries, it loses between 10 and 15 percent of its initial intensity.

"But beware!" is Fresquet's final comment. "If you apply too much fixative, it varnishes the colors and makes them shiny, and then you lose the highly prized matte quality that is characteristic of watercolor painting." That is Fresquet's final piece of advice.

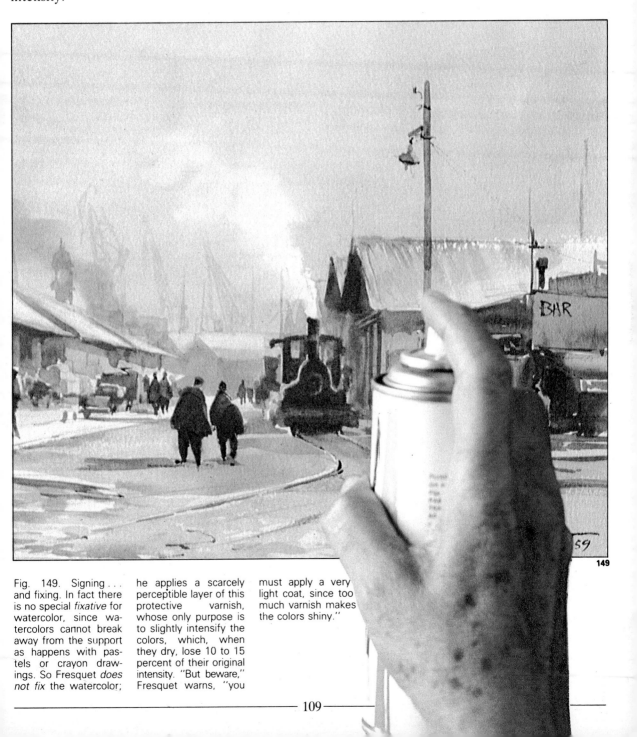

Fig. 149. Signing . . . and fixing. In fact there is no special *fixative* for watercolor, since watercolors cannot break away from the support as happens with pastels or crayon drawings. So Fresquet *does not fix* the watercolor; he applies a scarcely perceptible layer of this protective varnish, whose only purpose is to slightly intensify the colors, which, when they dry, lose 10 to 15 percent of their original intensity. "But beware," Fresquet warns, "you must apply a very light coat, since too much varnish makes the colors shiny."

That was painting with watercolor

To be successful you need, on the one hand, the genius of the artist and, on the other, the skill of the artisan. You cannot paint well without discipline, without playing the game according to the rules. With oil you can take it or leave it; the poor results of an impatient session can be remedied at a more peaceful one later. In watercolor they can't. In watercolor the impatient artist is doomed before he begins. He has to submit to its rules, to its demanding laws.

Bacon, the English watercolorist, said on the subject: *"You can only master watercolor by obeying its laws."*

But once you have mastered it—like Latin at school—unsuspected avenues of knowledge about drawing and painting, including oil painting, open up before you.

150

Glossary

A

Alla prima. Italian phrase that may be translated as "first time." It is applied to the technique of direct painting in which the picture is completed in a single session, with no preparation.

C

Cardboard. Thick sheet manufactured with wood binding, usually gray. Quality watercolor paper also comes with a cardboard support in a single compact piece. If the watercolor has to be reproduced photomechanically, the cardboard paper makes it impossible to use the *scanner* system, so it is preferable to paint on sheets of paper in this case.

Complementary colors. In terms of *colors of light*, the complementary colors are the secondaries, which need only a primary to complete and reconstruct white light (or vice versa). Example: when dark blue is added to yellow, which is composed of the green and red colors of light, white light is reconstructed.

Cutter. A special knife for cutting paper, consisting of a plastic handle into which an adjustable blade has been inserted. When cutting paper with a cutter, it is advisable to use a metal ruler.

D

Deckles. The uneven edges of drawing paper that is handmade. They are a feature of good-quality drawing paper.

Dominant color. The term *dominant* is in current use in music, where it means the fifth note of the musical scale, or the most important one; by analogy it is also applied to painting in relation to a dominant color, which may be one particular color or a range of *warm, cool, or broken* colors.

Dry watercolor. Dry watercolor does not exist as a special technique. In fact it is the usual classic watercolor method. The word *dry* is used in contrast to the term *wet watercolor*, which is a special technique.

F

Ferrule. On a paintbrush, the ferrule is the metal part that holds the sheaf of hair together.

G

Glaze. Transparent layer of paint applied first or superimposed on another color, which it modifies.

Grain. Disposition or direction of the fibers in a paper. The grain determines the roughness, and in watercolor painting papers we distinguish between fine grain, medium grain, and coarse grain. The last one has a rough texture that is clearly visible.

L

Liquid gum (masking fluid). Latex gum, which has a slight coloring in a liquid state, is used in watercolor painting to reserve small white forms, lines, or points so that they can be painted over and around. The liquid gum is finally removed by rubbing with the finger or an eraser and then the whites reserved at the beginning appear. Liquid gum can be applied with a thin synthetic brush, number 3 or 4. It is diluted with water, but there are always bits left that

can damage the brush if it is not carefully cleaned.

Liquid watercolors. Watercolor paints come in dry pans, wet pans, tin tubes, and jars of liquid. Liquid watercolor dissolves in water, is very transparent, and gives an intense but luminous coloring.

M

Medium. Term used to distinguish a painting process. For example: watercolor is a painting medium, oil is another, and so on. *Also:* A solution of acidified gum that, when mixed with water, eliminates any possible traces of grease, increases adherence and moistening, and generally improves the quality of the colors.

Mongoose hair. Brushes of mongoose hair are also good for watercolor painting. Mongoose hair, which comes from an animal like the sable, is slightly harder and provides a little more tension. It is also cheaper.

O

Ox hair. The ox-hair brush, made of selected hair from the animal's back, is a useful supplement to the sable-hair brush for watercolor painting. It is generally used in the high numbers, that is, in numbers 18, 20, and 24 brushes, for moistening and painting broad areas.

P

Pigments. Pigments are all the ingredients that, when diluted in a liquid, provide a color for painting. Pigments for painting usually come in the form of

powder and may be organic or inorganic in origin.

Primaries. The basic colors of the solar spectrum. The *primaries of light* are green, red, and dark blue; the *pigment primaries* are cyan blue, magenta, and yellow.

Protective varnish (fixative). This is the varnish applied to the watercolor when it is finished and dry to protect it. It comes in small jars and is applied with a brush. It intensifies the color and imparts a perceptible shine that is accentuated with two or more layers. That is the reason some watercolorists reject it; to them, watercolor painting must be matte.

R

Range. The word *range* comes from the system of musical notes (do, re, mi, fa, sol, la, ti). Invented in 1028 by Guido D'Arezzo, it means "a perfectly ordered succession of sounds." In painting it is applied to the succession of colors of the spectrum. By extension, the meaning of *range* in painting is "any succession of colors or tones that are perfectly ordered."

S

Sable hair. The sable-hair brush is undoubtedly the best for watercolor painting. It retains the load of water or color better than any other brush; the hair is tense but flexible and always keeps an excellent point. It is made with hair from the tail of

a small animal called the kolinsky, which lives in the Soviet Union and China. It is an expensive brush, but it lasts a long time and the quality is the finest.

Secondaries. The colors of the spectrum composed of a mixture of the primary colors in pairs. The *secondaries of light* are cyan blue, magenta, and yellow; the *pigment secondaries* are red, green, and dark blue.

Stag's hair. The stag's-hair brush is made in Japan with the hair of this animal and a bamboo handle, known as the *Japanese brush*, its quality is the same as or less than the ox-hair brush. The *flat* broad-ended Japanese brush (hake) is perfect for wetting or painting washes on broad backgrounds.

Sumi-e. This Eastern technique of watercolor painting is related in some aspects to the Eastern religious movement called *Zen*. It uses India ink diluted in water and a special brush of stag's hair with a bamboo handle.

Support. Any surface on which a pictorial work can be done. The specific support for watercolor painting is paper in sheets or mounted on cardboard.

Synthetic hair. A brush with this kind of hair has a slightly greater tension than sable hair and does not hold water or watercolor with the exact intensity guaranteed by the natural brush. Some manufacturers say that they are for amateurs. They have the

quality of resistance to chemical products.

T

Tertiaries. A series of six *pigment colors* that are obtained by mixing primaries and secondaries in pairs. The tertiary pigment colors are orange, crimson, violet, ultramarine, emerald green, and light green.

Texture. The visual and tactile appearance of a painted support. This appearance or texture may be smooth, rough, cracked, glossy, grainy, and so on.

V

Veduta. A landscape drawing with *views* of monuments of ancient Rome, fashionable in the 18th century all over Europe but particularly in England, where they were indirectly responsible for encouraging enthusiasm for watercolor painting.

W

Warping. Undulations in the drawing paper as result of wetting it, especially when the paper is thin and has not been mounted.

Wet watercolor. A special technique in watercolor painting that consists of painting on an area that has been moistened with water or has been recently painted and is still wet. This technique causes the water and color to run, producing a diffusion of forms and contours. The English watercolorist Turner was one of the first to use this technique.